C000217281

Contents

Introduction

Last year Amberley gave me the opportunity to write another book on South Shields. This resulted in *South Shields in 50 Buildings*. Much had been written about Harton Village and Amy Flagg, local historian, had pretty much covered Westoe Village. Therefore I decided South Shields needed representation. From our much-loved old Town Hall in the Market Place to the latest visionary building nearby, The Word, I have tried to cover many of the town's finest buildings. The map is intended as a guide to short walks around the various buildings that I have included. My husband Dave Barnsley was tasked with taking the many photographs that appear here and I thank him for his great images. I hope you enjoy the book and are encouraged to visit the places mentioned and take the time to appreciate the views that perhaps photos cannot do justice. While walking along King Street, in particular, I would encourage everyone to 'look up'!

Caroline Barnsley

Key

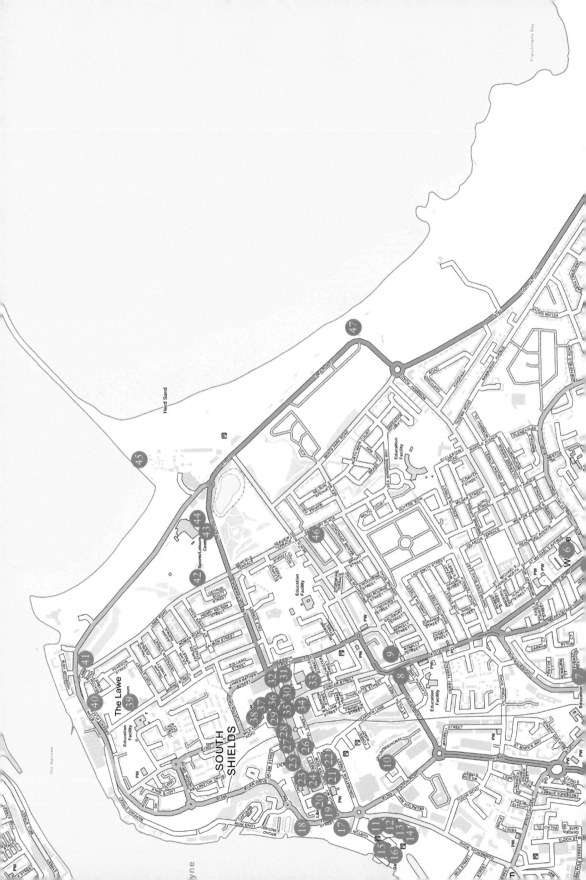

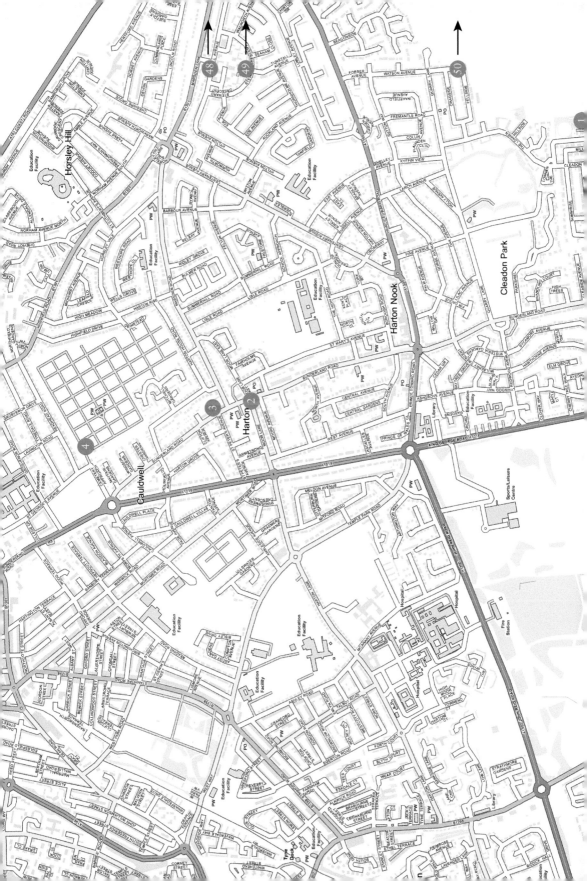

The 50 Buildings

1. Cleadon Water Works

Dominating the skyline of Cleadon Hills is the impressive and rather striking Cleadon Water Tower. Little has changed with this view in the last 150 years and the 100-foot tower was once part of the former pumping station. The plan of the tower is square with a central flue, around which are spiral stone steps. The tower consists of red brick with light coloured lime-rich mortar and rusticated sandstone quoins and one high level stone string course.

The early nineteenth century saw the population of South Shields and the surrounding areas increase substantially, leaving many working-class people living in slums areas. When the first outbreak of cholera arrived in 1831 over 200 people lost their lives, and concerns were raised on a national level about the quality of the drinking water. The population continued to grow rapidly during the mid-nineteenth century, which, coupled with the expanding requirements of the Industrial Revolution, saw a need for health improvements.

Something needed to be done and it came in the form of the Sunderland and South Shields Water Company. A number of wells were constructed, stretching from Cleadon in the north to Hesledon in the south, to use the clean water that was trapped in the magnesium limestone. The works were designed by Thomas Hawksley and were built between 1859 and 1862. Hawksley was an expert in his field as a nationally renowned, water supply engineer. He was born the son of a manufacturer in Nottingham in 1807. He received a basic education at the Nottingham Grammar School before leaving at fifteen years of age to join architect Edward Staveley at the Corporation as a surveyor.

When it was first built the plant was operated by steam and it took around 470 lbs of coal every hour to power the two Cornish engines. The water was piped away to a large circular underground reservoir. This reservoir held around 2 million gallons of water and when it was covered over in 1954 was said to be the largest covered dome in Europe. The well itself was 12 feet in diameter and 270 feet deep.

The plant successfully supplied clean drinking water to the people of the South Shields area, extracting around 3 million gallons of water every twenty-four-hour period. In 1930 the plant was electrified and the steam power plant was removed and replaced by electrical equipment.

The tower is easily the most recognisable feature of the station, and although it is oriental in style a bit like a Chinese pagoda, it was actually built to resemble the campanile bell towers of Italy. This large chimney provided a draught for the boilers as well as the dispersal of smoke, steam and waste gases. There is a balcony 82 feet above ground level and it has a staircase of 141 steps, which spiral around the central flue. A few years ago as part of 'Heritage Open Day' events I was lucky enough to be able to climb to the top, which is not for the faint hearted.

In later years the tower, together with the Paper Mill Chimneys of Grangetown, were used as navigational landmarks during the Second World War. A telephone was also installed at the top of the tower as its height and location made it an ideal lookout for enemy aircraft. In the 1970s Derwent Reservoir opened and there was no longer a use for the pumping station. The tower itself now houses a number of radio aerials and luckily has survived being demolished, while the other buildings on the site that made up the pumping station, such as the boiler house and engine house, have now been converted into luxury dwellings.

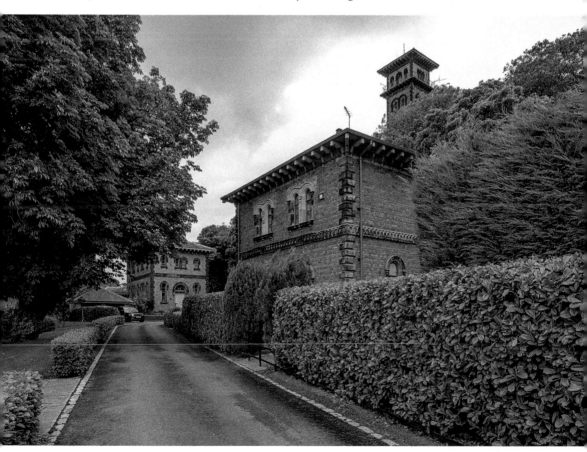

Outbuildings of the waterworks.

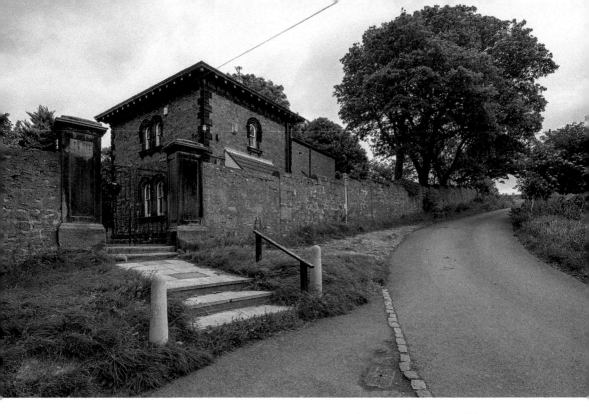

Above: Outbuildings of the waterworks.

Left: The campanile tower.

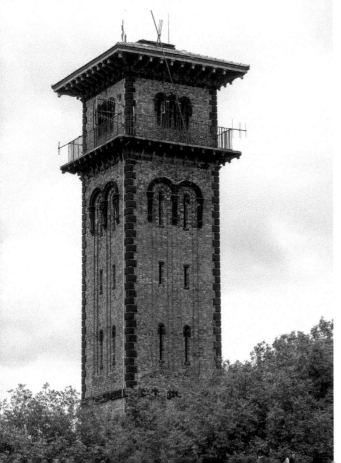

2. Harton Hall

Harton Hall was built for Joseph Mason Moore in 1881, replacing some earlier buildings on that same site. Surprisingly it was only a home for about thirty years and then it was divided into shops and living spaces early in the twentieth century. It stands on the crossroads of Sunderland Road and Moore Lane. Joseph Mason Moore was born in London in 1831 and came to South Shields with his wife, Sarah Jane, and daughter, Poppy, in 1853 and became a solicitor. He became a member of the town council three years later and was appointed Mayor of South Shields in 1870. He was also appointed town clerk in 1871 and held office for twenty-one years. Mr Moore frequently acquired land in Harton, building up quite a large estate. In 1875 he built a new village school in an agreement that allowed him to extend his estate to the south side of Moore Lane. On his death, the Harton Hall estate was sold in separate building plots, the large gardens becoming the Moore Avenue we know today. It also seems the house was reduced in size for a large section of the southern end must have been demolished allowing the avenue to be built. Thanks to Jean Stokes for this information. Last year her book *Harton Village 1900* was published and makes a very interesting read.

Harton Hall frontage.

Rear of Harton Hall.

3. The Old Ship Inn

On the exterior of the Ship Inn, above what used to be the front door, there is a coat of arms that contains the date 1803, making this a Georgian building, constructed during the Napoleonic Wars more than a decade before the Battle of Waterloo. The reason for the ancient glacial boulder and also another inside the churchyard opposite is not known? Some think it could have been a mounting stone used by travellers along the turnpike road to Sunderland, Stockton and beyond. Over the years a two-storey addition on the north side of the pub was made. Gradually we witness the plastering of the external walls with merely the quoin stones left to show its stone structure. Next came the blocking up of the central door, with the entrance on the north side of the building. Later, the addition of an off sales door to the east side of the building, where alcoholic drinks, crisps and sweets were on sale to the public, was of benefit. Just visible in the left-hand corner of the photograph is the doorway of the said off sales department. This was subsequently turned into an additional room within the pub, with a new entrance at the back of the building facing the new car park.

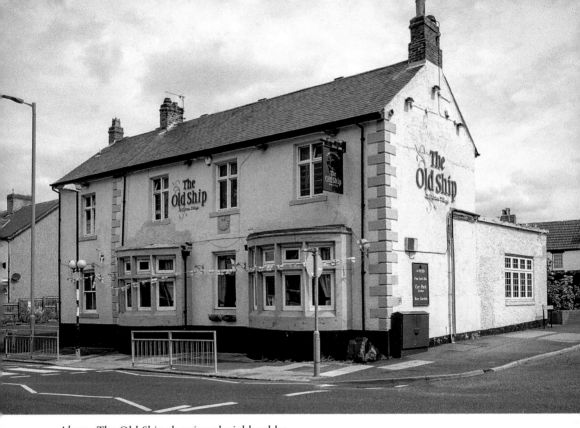

Above: The Old Ship showing glacial boulder.

Below: The Old Ship with rear extension.

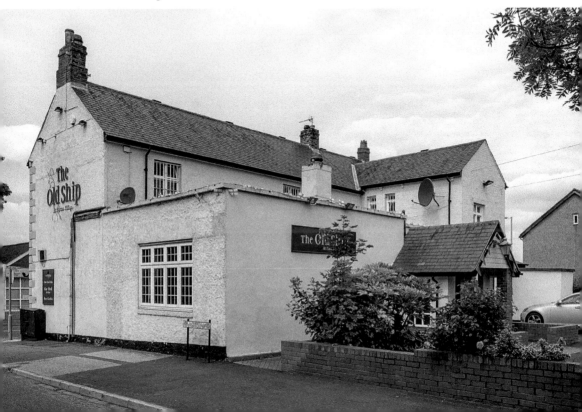

4. Harton Cemetery Lodge

The gorgeous Harton Cemetery Lodge is sited immediately to the south of the imposing entrance gates of the cemetery. Henry Grieves was the architect who designed the lodge in the domestic Tudor manner. It is built of coursed rubble with ashlar for quoins and window detailing. The lodge consists of two stories in an L-shaped plan. The gables have heavy barge boards and their upper parts are half timbered. The east gable has a ground floor bay window with traceried heads and the first floor is tiled. The north bay has a two-storey bay window. A square tower rises to above the eaves line, which in turn supports a pretty octagonal cupola. The imposing tall chimney stacks are of local stone. Originally the lodge consisted of the cemetery superintendent's house, a board room and an office.

Harton Cemetery opened in 1891, and covers an area of almost 50 acres. Anyone can be buried here irrespective of where they live or their religious beliefs. Some well-known local people are buried here, including members of the Readhead family, Captain Richard Annand VC and the family of James Simpson Kirkpatrick.

At the time of writing, the owners of the detached Grade II listed private dwelling would like to construct a new two-storey south wing. That part of the

Harton Cemetery Lodge.

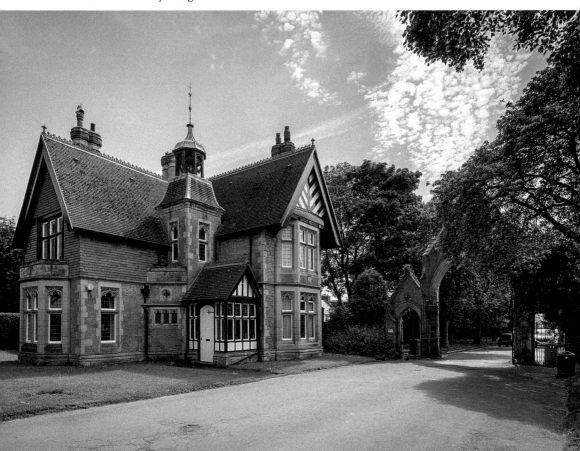

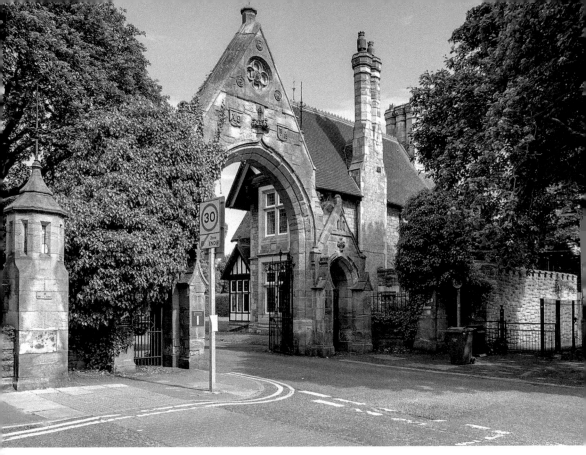

Grand entrance to Harton Cemetery.

building was hit by a German bombing onslaught in 1944 at the height of the Second World War. Plans submitted to South Tyneside Council show the extension would incorporate an expanded ground-floor kitchen-diner and two upper bedrooms. Following the Luftwaffe's attack, the wing was lost, and the south side rather patched up.

5. Westoe Court

'Westoe Court' is the name given to Nos 6, 8, 10 and 12 Ada Street in South Shields. These now residential apartments were originally home to the Westoe police and fire service. Looking at the building, to the left you can barely see the arched window, where the horse-drawn fire engine would have exited. To the right, the main door to the police station would have been beneath the crest. The charge room for the police station would have been entered by now bricked up doors. There was one cell in the building towards the back of the property. The police superintendent resided upstairs above the charge room. In later times, the building housed the Council's Weights and Measures department and boasted a weigh bridge outside in the roadway. The author was lucky enough to live here, at No. 8 in 1985, and it made a fabulous first home.

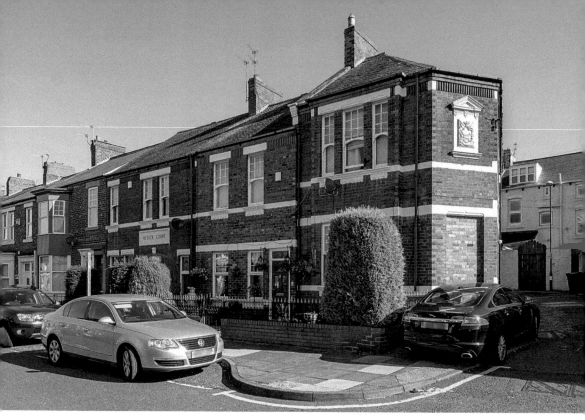

Westoe Court, Ada Street.

6. Ingham Infirmary

The first Ingham Infirmary was situated in the south-east corner of the plot near Horsley Hill Road, and was apparently a square plan building with a central courtyard. The infirmary buildings here are named after Robert Ingham, a major local figure in South Shields. He was elected the town's first MP in 1832 and remained so until 1868. From 1824, he lived at Westoe House in Westoe Village, where he died in 1875. Two years later the infirmary was opened in his honour. A plaque proclaims his 'public usefulness'. The infirmary expanded greatly during the twentieth century after the John Readhead Wing was opened in 1899, naming it after another prominent local figure. Further wings spread north, consuming gardens, and south, more than quadrupling its footprint by the 1970s, but always leaving the east front gardens untouched. By the early 1980s, the infirmary was redundant and the site became ripe for development. The main 1873 building is an impressive, detailed, Queen Anne-revival-style house with a deep cornice, segmental arched heads to the stone window surrounds and a Westmorland slate roof to top it off. The nurses' home to the rear has been developed into residential apartments and the boundary walls and gatehouses at Westoe Road have also been retained. At almost half the size of Westoe Village, the development at Ingham Grange is now a major part of the conservation area, and it is a commendable project.

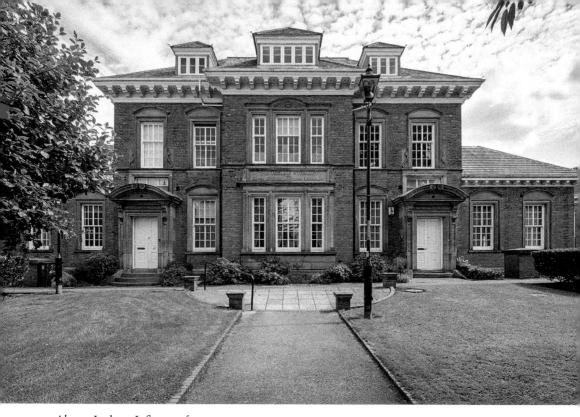

Above: Ingham Infirmary frontage.

Below: Rear of Ingham Infirmary.

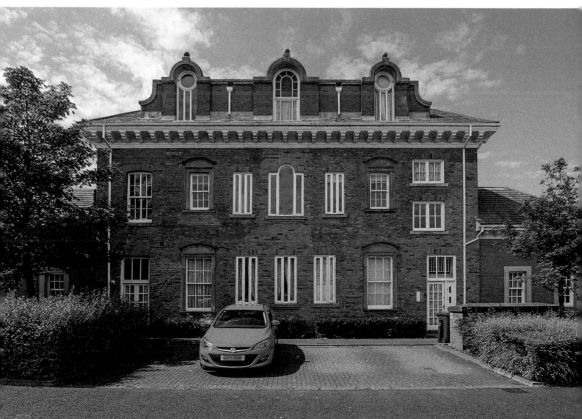

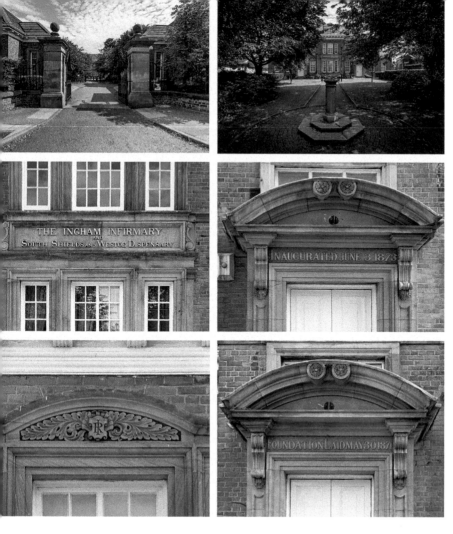

Fine detailing on the Ingham Infirmary.

7. The Cyprus Hotel

The original Cyprus public house was situated on the corner of George Potts Street and Chichester Road. The architects for the replacement were M. Wall & Sons of Albany Chambers. Plans for the current building were approved on 2 August 1900 and included a cellar and a ground floor with a bar and 'bottle and jug' room (off licence). The first floor was to contain a buffet and a billiard room, as well as a sitting room/newsroom. The third floor would be used as living accommodation consisting of three bedrooms, a living room and an indoor bathroom and lavatory. The site was owned by the executors of a Mr John Turnbull, who also owned the Victoria Brewery in James Mather Street, South Shields. Turnbull was in the brewing business for over thirty years and his initials can be seen in the fascia of the pub. The building, completed in 1901, includes a fascia made up of ornate bottle green tiles highlighted in reds and yellow, a luscious example of late Victorian architectural extravagance.

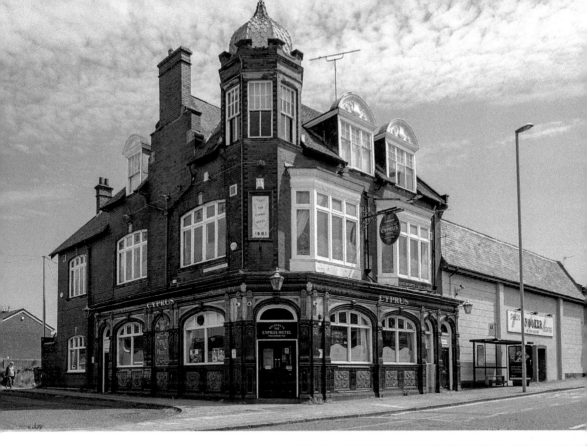

Above: The Cyprus Hotel.

Right: Tile detailing on the Cyprus Hotel.

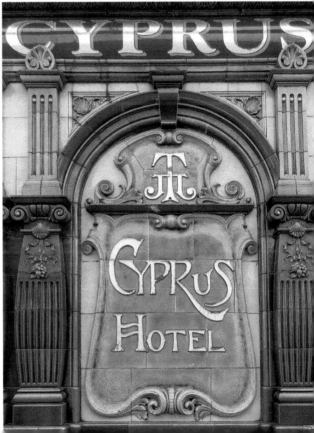

8. The Britannia

The Britannia, in Charlotte Terrace, at the bottom of Westoe Road is a fabulous example of a late Victorian pub. It was the work of South Shields architect John Wardle Donald, who lived in Hepscott Terrace and whose offices were in West Keppel Street. The Grade II listed building, built in 1898, is of red brick with stone dressings and a slate gabled roof. It has three bays and two storeys complete with attic rooms. Transom and mullion windows and elaborate gables decorate the pub. The arched Dutch gables have pleasing crescent moons and the splendid frosted-glass globe would have lit the way for many who had sampled the beer on offer. Early images show this is not the original lamp. A large four-sided glass lamp was in place but the old plaster mounting still remains. The wrought-iron railings to the small areas in front of the building are still intact and there was once a statue of Britannia there. Where did she go? The main entrance is on Westoe Road but it really looks like there were other doors off Claypath Lane.

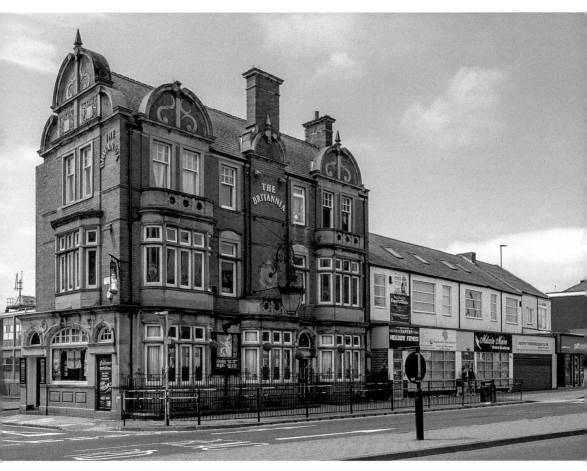

Frontage of the Britannia.

9. Town Hall

Our majestic Town Hall is not the only civic building in the borough but is certainly the most impressive. The Town Hall was designed by an architect named Ernest Fetch. His design and delivery of the building was the culmination of many years of hard work by the town council in seeking to replace the old Town Hall in the Market Place, which could no longer provide for the needs of the council. The building was finally completed and opened in 1910 after five years of construction and furnishing. The final cost of the project was £78,386.

The façade of the building is certainly most impressive. As you approach from the front, the detail and craftsmanship of the carvings and the bold proportions of the architectural features are sure to leave you in awe. The clock tower can be seen from miles around and we soon know about it if it loses time or if we forget to change the hour in the autumn or spring – local people let us know and it even made the local news when it stopped once! The clock tower itself sits to the north side of the building, as it is understood that a central position was not viable to hold the weight of the tower and its foundations. At the top of the tower are the bells flanked by statues depicting the four seasons. The tower is hollow, 146 feet high and can only be accessed by walking across the roof. The Westminster chiming clock has five bells, sounding on the hour and on the quarter hour. It was changed from a manual mechanism to automatic in 1956.

The Town Hall.

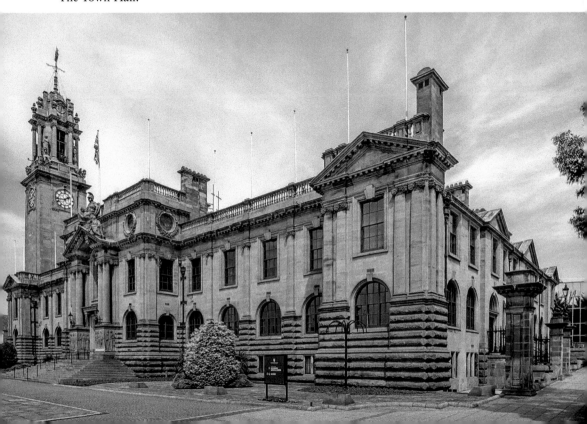

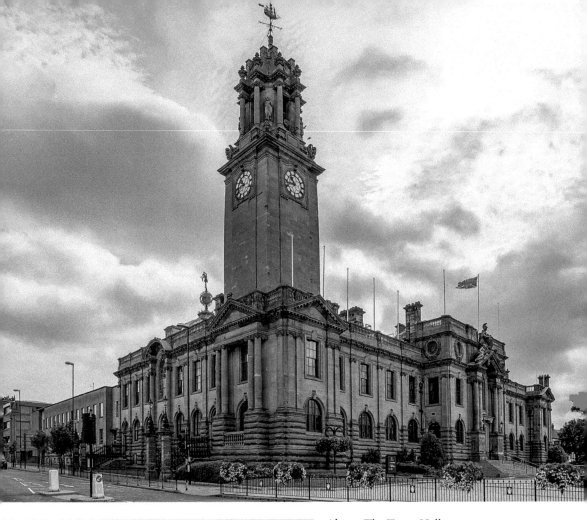

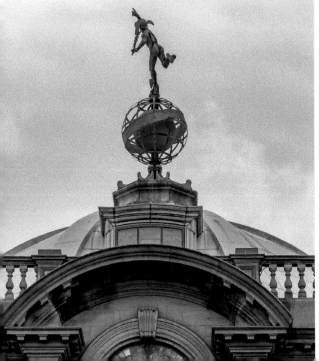

Above: The Town Hall.

Left: Mercury on the Town Hall dome.

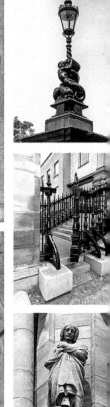

Fine detailing on the Town Hall.

10. St Hilda's Colliery Headstock

St Hilda's Colliery headstock dates to the mid-nineteenth century. The building is constructed from red brick with sandstone ashlar dressings under a flat roof. The building is three storeys high with a round headed entrance arch and iron gates to the front. To the right of this are three tall round headed windows with ornate iron glazing, ashlar blocks and keystones. Above this is a moulded ashlar sandstone band and then a moulded sill band with a pair of glazing bar sashes. Above there is another sash to the left, and to the right is a large round headed window. To the roofline is an open ashlar pediment and a raised brick parapet with ashlar coping. To the rear of the building is a single iron head stock over the mining shaft. The building was restored in the late twentieth century (around 1985). The structure is of historic interest not only as a colliery headstock dating from the mid-nineteenth century but also of interest as the last surviving building of the St Hilda's Colliery, which was originally situated on the site. The colliery opened in 1825 and was subject to various explosions, which led to a significant development of ventilation, lighting and safety within mines across the country.

A disaster occurred when, between 8 a.m. and 9 a.m. on 28 June 1839, an underground explosion ripped through the pit. Around 100 men managed to escape to the surface, some of them suffering the effects of choke damp. Many of them, with admirable courage, went back down to try and rescue their colleagues. Families of the miners were quickly on the scene. One witness account described the scene below ground as 'that of the grave itself. The men were moving about like spectres in a thick darkness, with blurry glimmerings from more than usually bedimmed lamps, seldom uttering a word, except in suppressed tones, and doing their duty to the dying and the dead in a solemn manner that was truly affecting'. Some of the dead had been overcome by gas and others burned. The funerals took place quickly, most of them not far away at St Hilda's Church. Today, the graves lie under the bottom of Station Road, close by where a memorial to the disaster was put up at the end of the 1980s. G. L. Atkinson wrote a book in 1989 called *Killed by Candle: the Explosion at St Hilda's Colliery* from which the above quote originates.

The year 2018 saw the building get a new lease of life. Now, by appointment only, you can visit and see the newly created office space and small museum.

St Hilda's Colliery headstock.

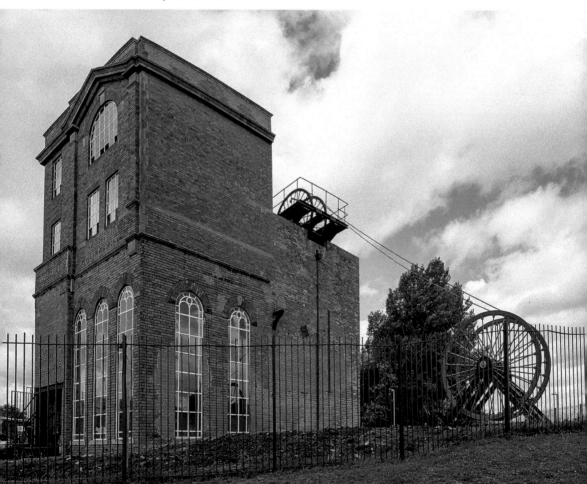

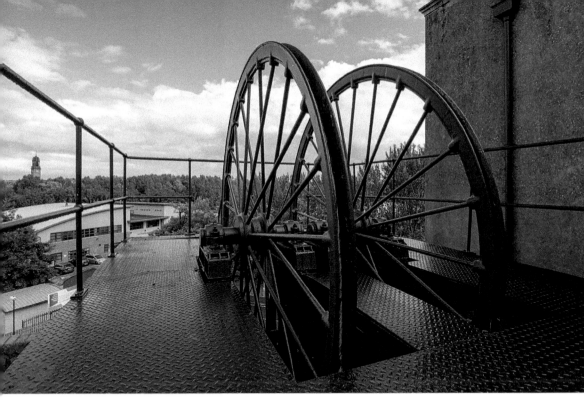

St Hilda's shaft winder.

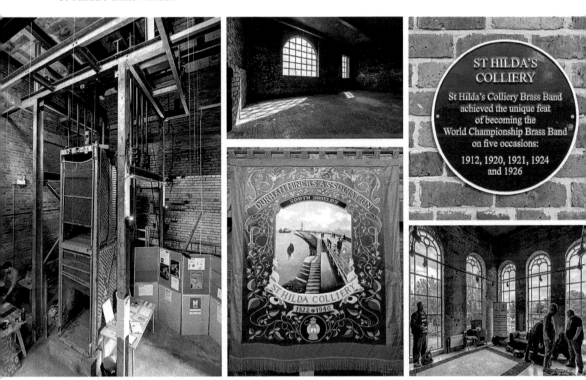

Inside the refurbished St Hilda's Colliery.

11. The Steamboat

No. 23 Mill Dam is a former shop dating to the early nineteenth century and now forms part of the neighbouring Steamboat public house, which is Grade II listed. The building is two storeys, with attics, and is constructed from render under a slate roof. A mid-nineteenth-century shopfront has been added, consisting of two windows and a central door. The shopfront is eccentrically detailed with a cornice supported by four long, richly carved scrolled brackets that extend halfway down the shopfront. Each of these is topped by a carved grotesque head. The building dates to the early nineteenth century and is constructed of render under a hipped roof of Welsh slate. The building is two storeys with three bays to the first floor in Coronation Street and one bay opposite the Mission to Seamen. The first floor also includes rusticated quoin detailing. A public house front was added to the building in the mid-nineteenth century. Formerly the Locomotive, the Steamboat is one of the town's last proper olde worlde pubs.

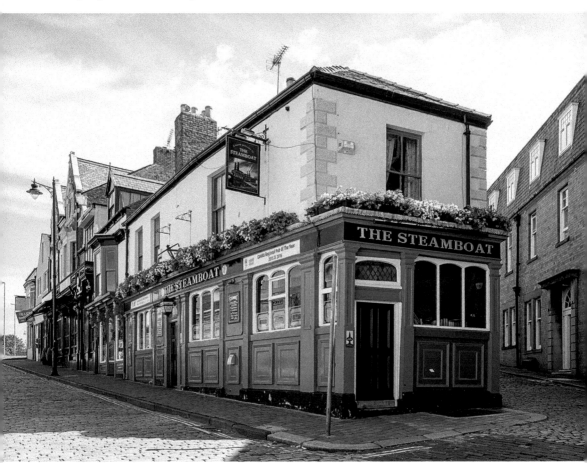

The award-winning Steamboat.

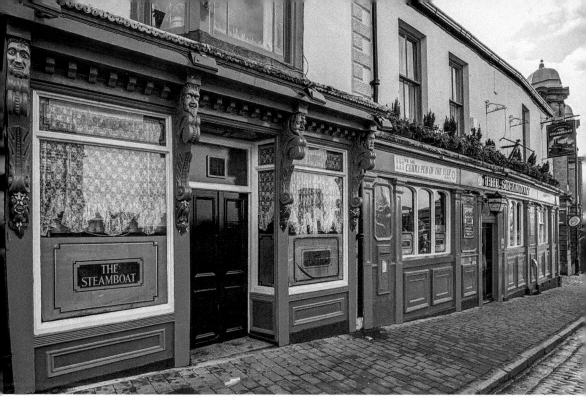

The Steamboat with grotesque carvings.

12. Mission to Seafarers

Few institutions are as old or as respected in the town as the Mission to Seamen. Although shipping in the town has decreased over the years, the work of the Mission to Seafarers at the Mill Dam remains vital among north-east ports. Mission work among seamen in the town dates back to just after the Napoleonic Wars. There was a 'bethel' in Wapping Street, for example, and another at Tyne Dock, which tended to the needs of the arrival of crews into the narrow streets along the riverside. The Church of England Mission to Seafarers began work on the Tyne in 1857 and the present premises are a far cry from its early floating 'church'. This floating church was a twenty-gun sailing brig, HMS *Diamond*, which had served as a hospital ship during the Crimean War. She berthed at the Ha'penny Ferry Landing near Comical Corner in 1866. Her interior was fitted up with a chapel capable of seating up to 400 men, a reading room for sailors on the lower deck and a school for 300 boys on the upper deck. She was consecrated at Easter 1867 and was renamed the *Joseph Straker* after one of the committed men of the Mission who had raised a large share of the £1,000 for the conversion. She remained in use for eighteen years until, eventually overcrowded and showing signs of rot in her timbers, a purpose-built 'bethel' was constructed at Mill Dam, on the site of the old bottle works. These premises comprised a church, reading and writing rooms, classrooms and accommodation for officers and apprentices and at its peak, at the turn of this century, catered for more than 1,000 seamen a year.

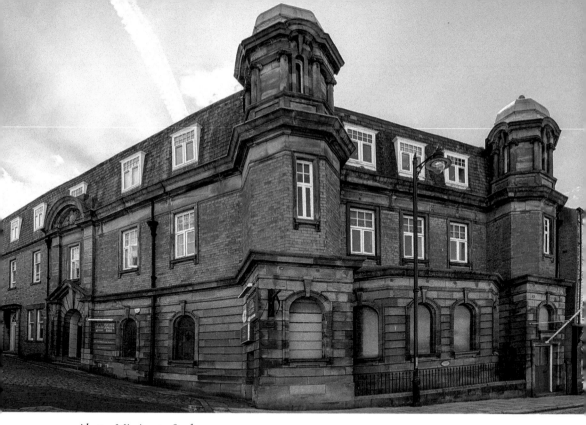

Above: Mission to Seafarers.

Below: Chandler's Buildings.

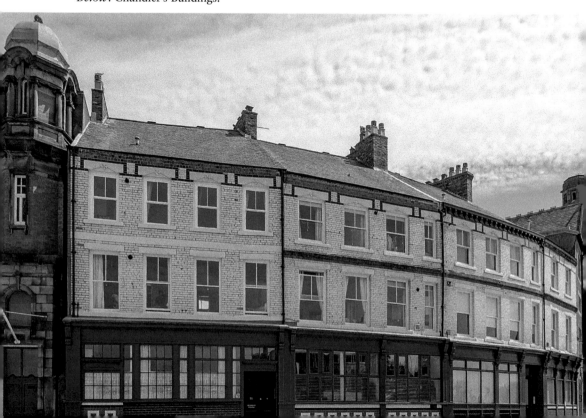

13. Chandler's Buildings

Formerly known as Chandler's Buildings, Nos 53–67 Mill Dam has an historic association to the area as well as a strong visual presence. They form a neat three-storey late Victorian curved terrace, facing toward the Customs House. They retain prominent upper levels in white glazed terracotta, which is renowned for repelling industrial stains. Decorative eaves and string courses also feature. Vertically proportioned windows survive at upper level, as do an authentic mix of ground-level windows and shopfronts, some with metal grilles still intact. Unity to the group comes from the common colour scheme and the largely unbroken sweep of the roof and brick chimneys. In the 1980s, Winskell Chartered Architects converted the ground-floor commercial properties and upper floors former sailors' boarding houses to apartments for Enterprise 5 Housing Association.

14. Unity Hall

Unity Hall was built as a charitable gift of the Bishop of Durham and was originally a nineteenth-century meeting house. The red-brick building is at the opposite end to that of the Missions to Seafarers. Its strong Gothic vertical form

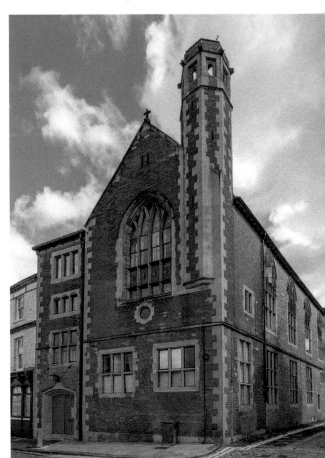

Unity Hall frontage with steeple.

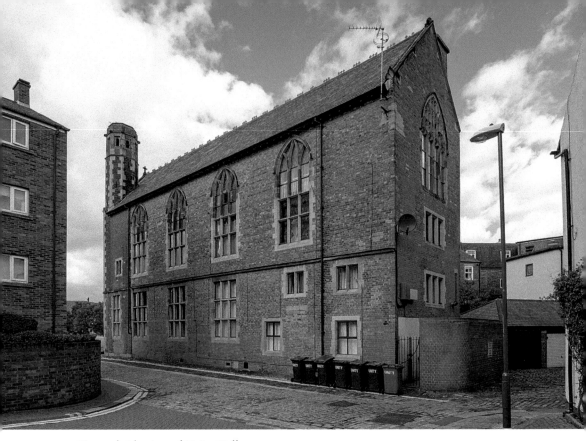

Unusual side view of Unity Hall.

with irregular gable and bell tower are emphasised by a high first-floor arched window. Stone mouldings and quoins contribute to its authentic character. There is a narrow flat roofed four-storey front extension with a vaulted stone doorway. It really complements the character of the original building and is hardly recognisable as an extension. Unity Hall has now been sympathetically converted into eleven luxury apartments.

15. Customs House

The Customs House dates to the mid to late nineteenth century (around 1863–64) and was designed in the classical style by the architect and borough engineer T. H. Clemence. The building is square in plan and constructed from white brick with stone dressings. The ground floor consists of an originally open arcade (now enclosed) with three large sunken arches. Above these arches are three bays divided by coupled Corinthian half columns supporting a large pediment to the centre (the sculpture has since been lost). At the centre of the building, above the principal entrance, is a coat of arms carved by T. W. Howe. To the rear of the building is a three-bay extension

by L. H. Morton in 1878 for use as offices for the Local Marine Board. The building is primarily of historic interest as a customs house dating from the mid to late nineteenth century. It is also significant in that it symbolises South Shields independence from Newcastle as a customs port in 1848, and it remained in use as a Customs House up until the late twentieth century. After the decline of the shipping industry, the building fell into disrepair and was left derelict during the 1960s and 1970s. In the 1990s, Tyne and Wear Development Corporation funded development of the Customs House, turning it into an arts and entertainment centre for the people of South Tyneside and afar. This was done by refurbishing the original building and adding a new purpose-built theatre. The Grade II listed building opened its doors in November 1994, providing South Shields with its first theatre and cinema in a long time. Today the Customs House boasts a theatre, cinema, art gallery and the Green Room restaurant. Long may it continue!

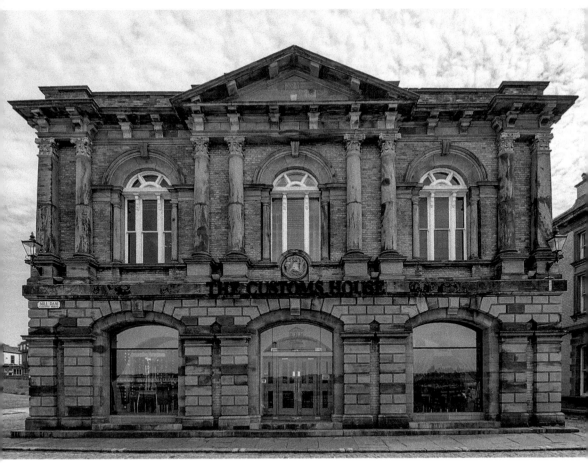

The grand frontage of the Customs House.

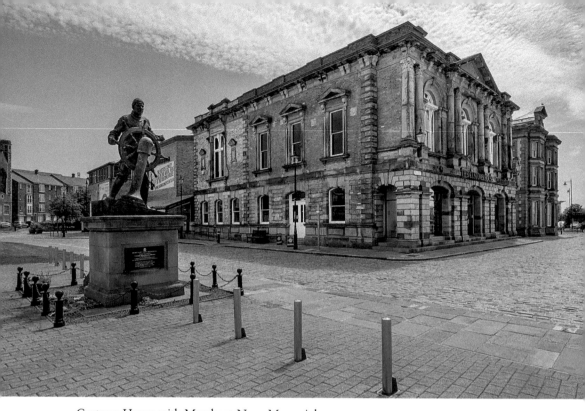

Customs House with Merchant Navy Memorial.

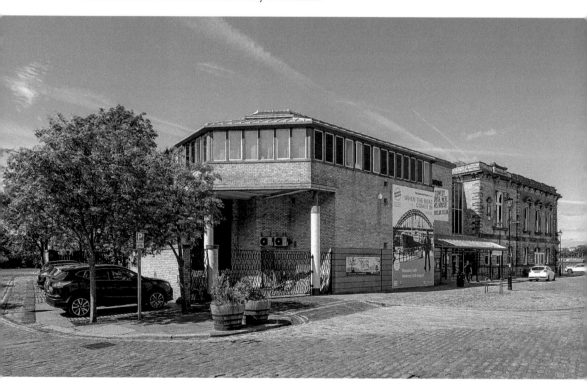

Customs House's extension to the rear.

16. River Police Offices

The River Police building dates back to the mid to late nineteenth century (around 1886). The front is constructed of sandstone ashlar from top to bottom, with buff-coloured brick and stone dressings to the three remaining floors. There are three storeys and three bays, the central bay forming the grand entrance to the building. Glazed brickwork forms the wall of the left gable. Toward the top of the structure is a rectangular panel carved with an inscription that reads 'RIVER POLICE AND TYNE PORT SANITARY AUTHORITY'. The outer bays have bay windows on all three storeys, each of the three windows having an architrave. The roof is adorned with an elaborate pediment that rises skyward. The 1980s saw the building converted into smart residential apartments. What a fabulous location to reside, overlooking our beautiful river.

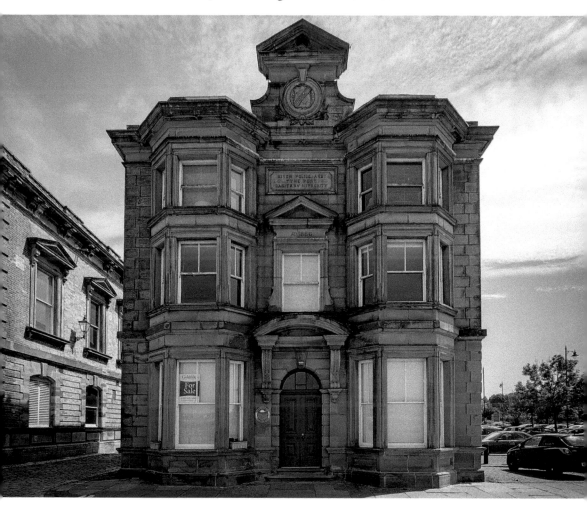

River Police Offices.

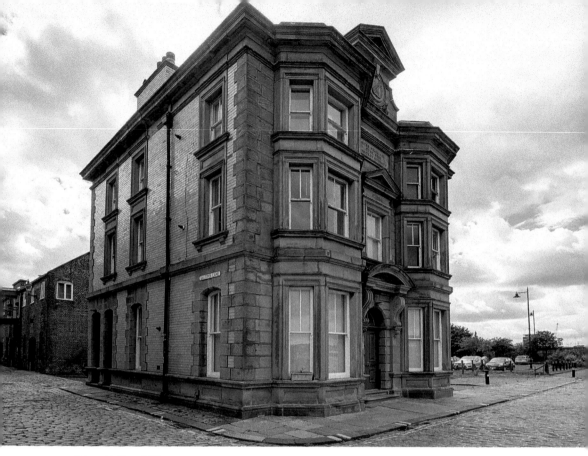

River Police Offices.

17. BT Building

The North East and South Tyneside Council joined forces to develop our riverside and one of the first developments was the BT Building at Harton Staithes. The four-storey building, at the gateway to the town centre, comprises of 58,836 square feet of offices and is clad in glass, sandstone and metal panelling. Its shape makes me think of two ships facing out to the river and the metal panelling is reminiscent of the heavy industry of shipbuilding that took place on the Tyne. Newcastle architects +3 Architecture beat a number of regional and national architects for the contract to design the centre. The scheme was designed to connect the town with the river and construction work started in May 2010 and was completed in September 2011. This was the first building to be constructed in the 35 hectare waterfront regeneration area. The site was originally former docks and the architects' brief called for a bold contemporary scheme that would establish a quality benchmark for future developments in the area. The simple bold form and language have been highly praised by the Commission for Architecture and the Built Environment. The building remains a bit controversial, taking a prime spot on the riverside. I suppose it's a bit like Marmite, you either love it or hate it.

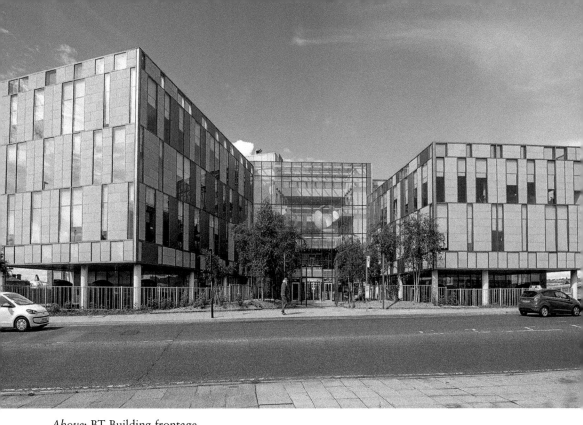

Above: BT Building frontage.

Below: Side view of BT Building.

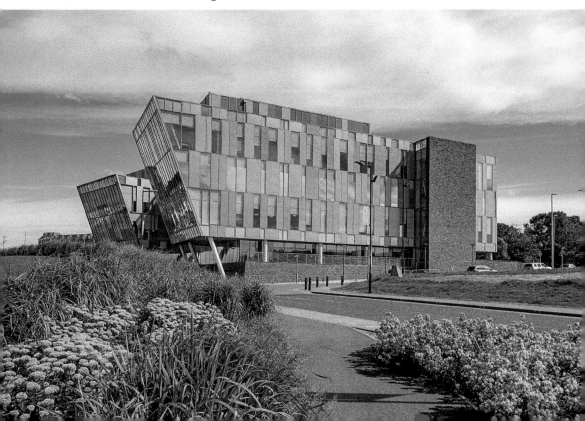

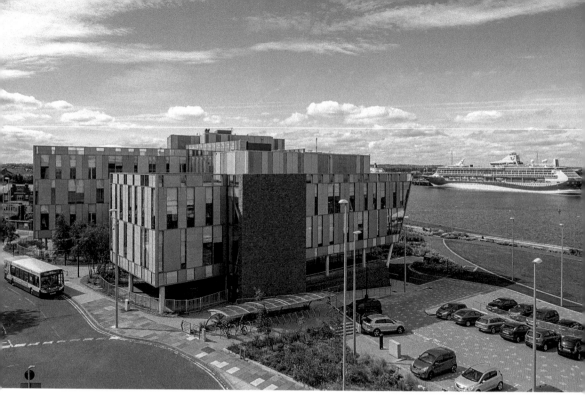

Above: BT Building as seen from The Word.

Below: Alum Alehouse.

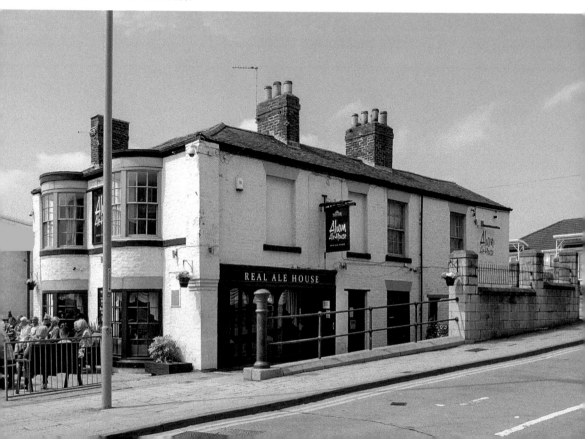

18. The Alum Alehouse

The Alum Alehouse dates to the early nineteenth century and is constructed from ashlar, which is now painted, under a roof of Welsh slate. The Grade II listed building has a chequered past. A popular rendezvous for seamen, it had an unsavoury reputation. Arguably one of the oldest pubs in the town, it did have a spell as shipyard offices. While being converted into Davell Contract Furnishers, army insignia was found on a wall above one of the fireplaces. It seems at some point the Alum House had been used by the Home Guard and the former managing director of the Tyne Dock Engineering Company became their colonel. Today, with its contemporary outdoor decking and fabulous view over the river, it regularly appears in CAMRA'S good beer guide – a real gem of a pub.

19. The Word

Not many people realise that the plan to design and build The Word was launched as a competition. One of the architects from Faulkner Brown, whose design was successful, told me about the project. Steve Dickson revealed the ideology behind The Word:

> Approaching the proposed site for The Word, it was immediately apparent that this was going to be a special opportunity. The site was occupied by an existing unremarkable 1960s office development, Wouldhave House, but the location on the corner of South Shields Market Square and adjacent to the banks of the River Tyne was outstanding. Historically, the Market Square had been a fine Georgian public space which had been severely bombed during World War II, leaving only the Grade I listed old Town Hall at its centre and St Hilda's Church to the south. All of the other distinguished buildings had been lost or replaced over the years with flat unremarkable facades. It was clear from the competition brief that South Tyneside Council had high ambitions for this project and clearly stated that they wanted an iconic building to help drive new developments for the town. After walking around the site and its surroundings, we strongly felt that the architecture should announce a gateway to the town and it should link the design philosophies of the new riverside park and river, as much as presenting a façade attitude onto the square. The form of the building also had to be representative of its contribution to society: it had to be democratic, a community gathering space of equal parts and South Shields agora. The purity of strength of a circular building emerged from all of the influences and requirements set out by the urban grain and the social and community ambitions. Whilst the competition was relatively short and intense, the scheme developed well to include two full height glass insertions, one announcing the entrance of the building which looked back towards the market and the town beyond, whilst the other opened the façade

onto the river and the new park. In some ways, this move seemed symbolic of the past and the future coming together and being tied by the circular form. Internally, a large central atrium gave a visual clarity to the scheme, allowing a grand gesture of civic quality to link all the internal activities. This was very much an open and engaging plan, modern in its expression. It was not a temple for silence, but a place for sharing knowledge, where the young could learn from the old and the old could learn from the young. And so the vision of the building was born. South Tyneside Council granted us the privilege of 'making the internal activities inspiring' Why would I want to come back? Why would my daughter want to come back? Why would my mother want to come back? These were our challenges, and incredibly interesting challenges, given the relationship between the real and the virtual world we currently live. We felt a true paradigm shift was possible.

Whilst we explored these challenges, we continued to investigate the site and its context, and developed an architectural language which responded to this. We also explored the notion of how we communicate, how we arrange symbols and sequences to create knowledge. We explored alpha numeric symbols and sequences, computer sequences and codes, and we explored natural sequences such a tidal movement and natural colour temperatures in the sun's rays. All of these symbolic and contextual influences were woven into the building's language, creating its architectural design rules. We wanted a totally immersive experience, but an experience which delighted.

The riverside provided a rich cultural heritage: we discovered that the Romans harvested salt on the site in the 3rd Century; that circular crown glass was made at the Cookson glassworks in the early 18th century and that the coal and ship building industries came to the fore during the industrial revolution. These influences were interpreted into the building in a variety of ways. The salt context is represented in the fine quartz aggregate of the white pre-cast concrete. The circular glass patterns are represented by the feature chandelier in the main atrium, whilst the coal is represented in the external black scrapped concrete plinth, the engineering of steel ship building is expressed in the large glass window structures and the red oxide primer as the signal colour used throughout the building.

Communication codes are represented throughout the building: the temperature of the sun is delivered in the feature chandelier which gradually delivers warm light at 2000 Kelvin, simulating morning sun to the bright blue 6000 Kelvin light of midday and back to a warm evening glow. This feature is not a gimmick: it is representative of nature's circadian rhythm which promotes wellbeing within the built environment. The natural code of tidal patterns is interpreted in the window sizes and frequency; binary and bar codes are expressed in the aesthetics of the ceiling design and the façade design. All of this rich contemporary symbolism is wrapped by a circular façade likened to the pages of an open book, inviting the reader into the depths of creative

writing, of knowledge, of delightful storytelling, of individuality and ideas. The building opens itself for exploration which brings us back to the contents and the paradigm shift in community buildings.

Our studies and exploration determined that the architecture and the physical environment were not solely to be a repository for books. They had to be a creative engine for the local community, the region and the country. We were determined that an individual building could make such a difference to society, and as such, we carried responsibility for the provision of the creative environments and facilities to deliver this creativity. We wanted to allow ownership. We wanted to give each visitor the ability to create their own content and in doing so, use the gift of curation to support this creativity. We wanted the building to be a gateway to cultural, social and business knowledge. We wanted to capture demographic profiles not associated with this building type. We wanted to make the building EXCITING.

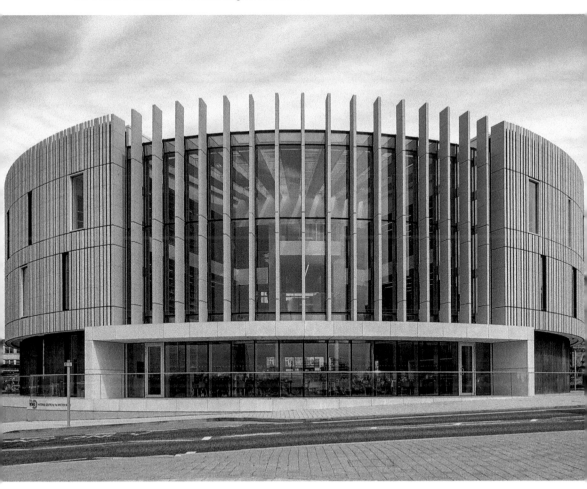

The Word from the riverside.

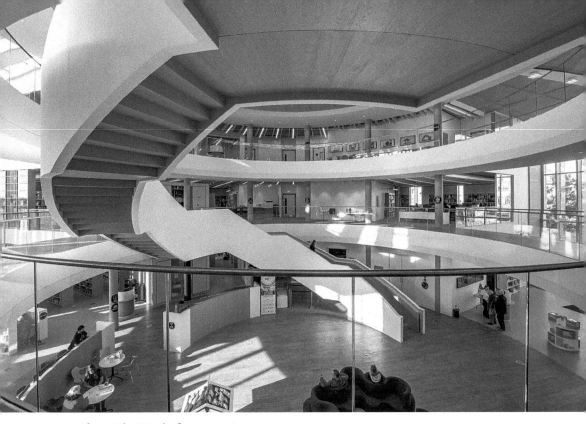

Above: The Word's floating staircase.

Below: The Round at the top of The Word.

20. Old Town Hall

Hodgson's *The Borough of South Shields* tells us 'The Dean and Chapter, in or around 1768, erected the quaint edifice now indifferently known as the Town Hall and the "cross"'. The builder was a South Shields man named Hunter. Although there is no record or other evidence of this fact, it is quite possible that the structure derives its popular name of the 'cross' from the pre-existence of a market cross. When the structure was under repair in the summer of 1901, it was found that the central pillar did not support the building and was entirely detached from the floor and surmounted by a capital. The pillar, which stands on a square base of four steps, appears to be of a different kind of stone from the rest of the building. On the north side of the pillar the legend 'Durham 18 ¼ miles' is carved. The open basement of the Town Hall, supported on eight pillars and arches, was intended for use as a corn and provision market, and before this a market of sorts was held in a crooked narrow street along the riverside of the eastern part of the town. This so-called market was promptly transferred to the Market Place.

Old Town Hall.

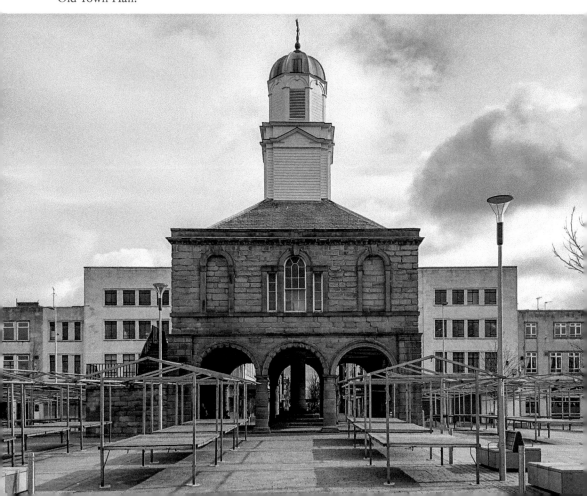

21. Trustees Savings Bank

The Trustee Savings Bank building dates to the early to mid-nineteenth century (around 1841), and was designed in the classical style by the architects J. and B. Green. The building consists of a five-bay elevation to Cornwallis Street and three bays to Barrington Street. The building is two storeys high and constructed of sandstone ashlar with rusticated quoins under a flat roof. To the ground floor are timber sliding sash windows with semi-circular heads and keystones. The first floor consists of sash windows with alternating triangular and segmental pediments. An extension has been added to the rear, which was designed by J. H. Morton & Sons back in the 1950s.

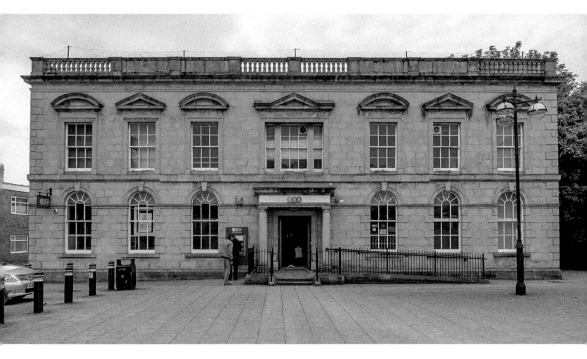

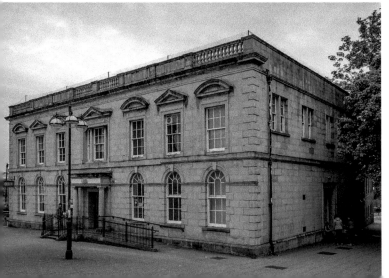

Above: TSB Bank frontage.

Left: TSB Bank from the side.

22. No. 16 Barrington Street

This highly impressive building dates back to the late nineteenth century and was constructed for the South Shields Poor Law Union. The building is designed in the English Domestic Revival style by the architect J. H. Morton. It consists of two storeys with attics, five bays to Barrington Street and three bays to Nelson Street. The building is constructed from red brick under a hipped roof of Welsh slate, with a modillion eave cornice. Each of the bays is delineated by brick pilasters and windows. The main entrance to the front is semicircular and hooded and constructed from sandstone, and is highly decorated and framed by an ionic door frame. Above this door is an oriel window. Also to the upper floors are three large dormer windows and a continuous sill band. The building was extended to the rear in 1904, also by Morton, and is designed in a similar style with three storeys, five bays and decorated with a stepped gable. South Tyneside Fostering Service staff are lucky enough to have this building as their workplace.

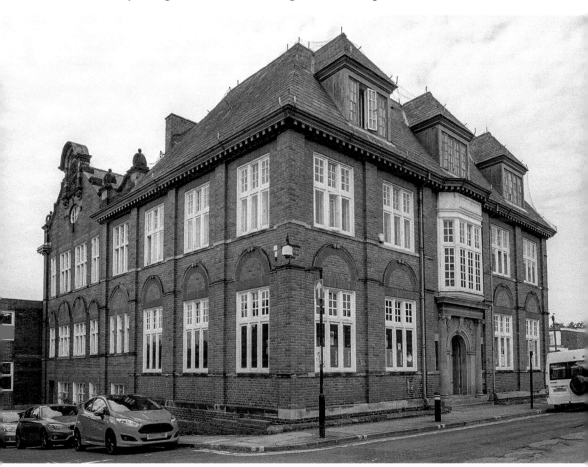

No. 16 Barrington Street.

23. Lloyds Bank

Lloyds Bank is housed at Nos 101–103 King Street. This ornate Renaissance Palazzo-style building was designed by architect J. D. Kitson and was completed in 1913. The date is etched at the top the building in Roman numerals as 'MCMXIII'. The ground-floor basement supports a portico of giant Roman Doric columns rising through two floors, the three centre bays being set back behind them. Above this is a full entablature breaking forward over the columns, the frieze being decorated with circles. The elevation is then completed with a very deep parapet. Back in 1913, the building was No. 76 King Street, the telephone number was 247 and the bank manager was Mr C. Alderson. In 1917 the building was shared with J. H. and H. F. Rennoldson, solicitors, and their telephone number was simply 121. The origins of Lloyds Bank stretch back to 1865 when John Taylor and Sampson Lloyd set up a private banking business down in Birmingham. With the outbreak of the First World War, Lloyds employed women clerks for the first time.

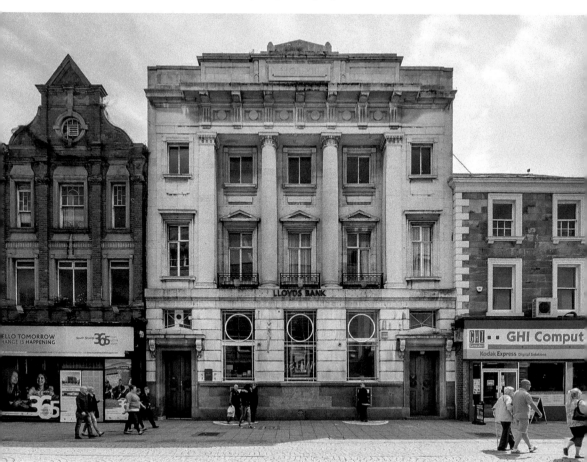

Lloyds Bank.

Lloyds Bank detailing.

They replaced men who had joined the armed services to fight for our country. Six women were taken on at the start of the war and by the end there were more than 2,000 on the payroll nationally. However, this change was not welcomed by all. Many felt that the job was too taxing for women, and they should look for work where 'gentleness and sympathy are called for'. The end of the war also marked the end of the general recruitment of women.

24. Theatre of Varieties

The grand entrance to the Theatre of Varieties was designed in the nineteenth century (around 1898) by the architect Frank Matcham. The building is of three storeys and constructed from terracotta, which has been painted over. The ground floor consists of a modern shopfront, currently local bakery Cooplands. Above it

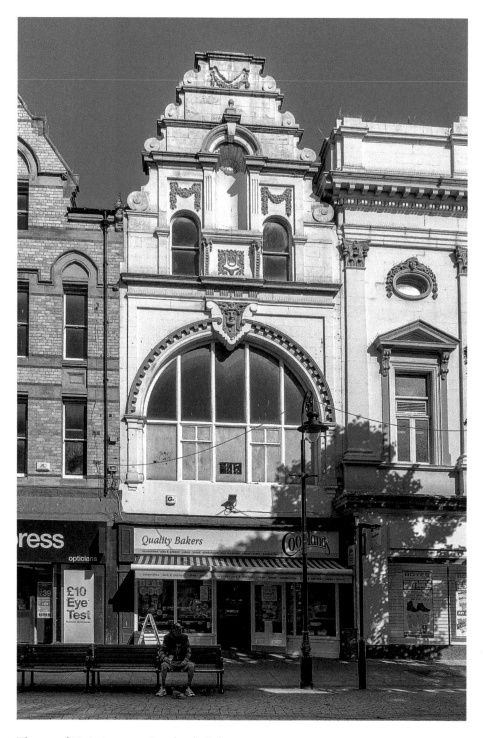

Theatre of Varieties, now Coopland's Bakery.

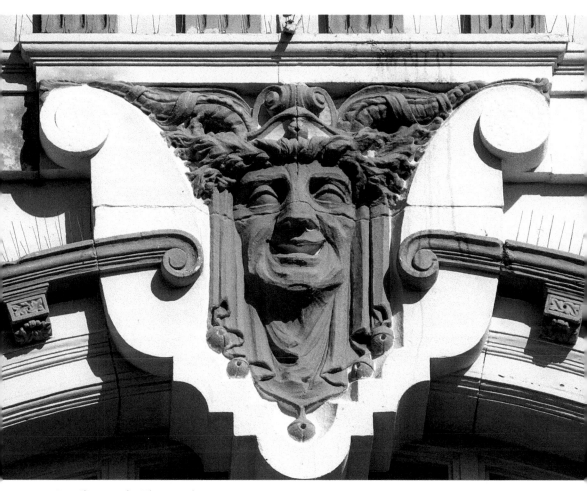

Detailing on the Theatre of Varieties.

is a free interpretation of classical details in the manner of a seventeenth-century frontispiece. The first floor is filled with a large semicircular arched glazed opening. To the second floor are two semicircular hooded windows flanked by a semicircular hooded niche, which rises to the first stage of a stepped gable. Each of the three steps of the gable is flanked by scrolled brackets. Its doors opened with a variety show on 13 February 1899.

25. Theatre Royal

There were two theatres rubbing shoulders together on King Street in the late 1800s. The first to be built was the Theatre Royal, which opened on Monday 21 May 1866, with a production of the comedy 'Extremes'. The second was the

Empire Palace, which opened in February 1899. Wybert Reeve, himself a well-known actor, was the first lessee of the Theatre Royal. Both theatres have been gutted internally and converted into retail premises, although their front façades and parts of the rear of each building do still exist externally. The front façades are Grade II listed. The Theatre Royal was designed by renowned theatre architect C. J. Phipps. On opening, the theatre had capacity for 1,560 persons and the dimensions were stated as being 31 feet deep by 54 feet wide.

In 1887 the theatre was refurbished for its then lessee Thomas Appleby and reopened with a production of W. S. Gilbert's *Pygmalion and Galatea* and rounded off with the comedy-drama *The Spittalfield's Weaver*. *The Shields Daily Gazette and Shipping Telegraph* reported on the changes in their 30 August 1887 edition, stating

Under most auspicious circumstances the Theatre Royal, South Shields, was reopened last night. During the past three months it has been closed for cleaning and redecoration. That the various firms entrusted with this work have employed their time profitably is evident, for every part of the building bears a bright and

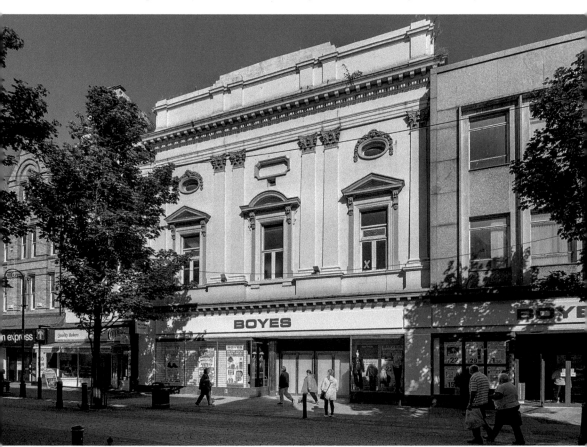

Theatre Royale, now Boyes retail.

Window detail.

clean aspect. The staircases have been repapered and painted while that leading to the dress circle has been transformed from a dingy passage into a dramatic picture gallery. Portraits of Henry Irving, J. L. Toole, Charles Wyndham, and W. Calder and a host of other stars of the theatrical profession hang upon the walls. These are surrounded by the new lessee as his chief characters. On entering the theatre proper an artistic scene presents itself. The front of the gallery and dress circle has been painted in French grey, picked out with vermillion and gold, while the velvet cushions running along the top of the latter have been partially hidden from view by deep lace. The private boxes have been painted and the brass work has been relacquered. These improvements, together with the new curtains, give them a charming appearance.

The Theatre Royal ceased as an entertainment venue in 1933.

26. Greenwoods

Nos 67 and 69 King Street date to the mid to late nineteenth century (around the 1870s) and are designed in the French classical style. The building is made of sandstone ashlar to its front on King Street and first part on Waterloo Vale. The remaining back of the building is constructed from red brick under a roof of Welsh slate. The building is three storeys with attics and six bays to the front, with the centre two set back. The building is decorated with the use of continuous sills, cornices and a deep parapet. Flanking these recesses are end pavilions with triangular pediments rising into the parapet. Above is a very steeply pitched roof with small square flat tops. These are decorated with cast-iron cresting. The structure has been home to retail before including River Island and is now Greenwoods, the gentlemen's outfitter.

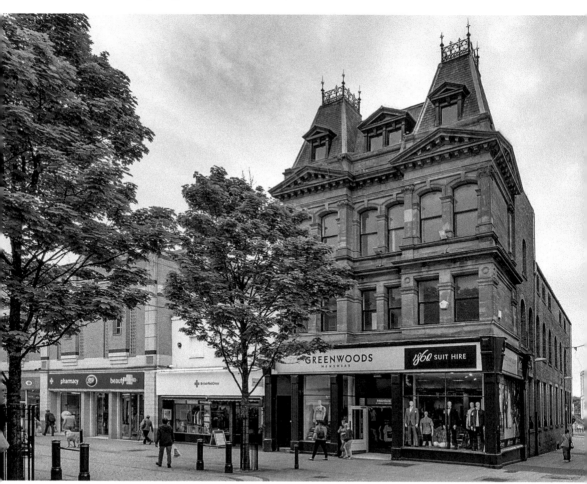

Greenwoods frontage.

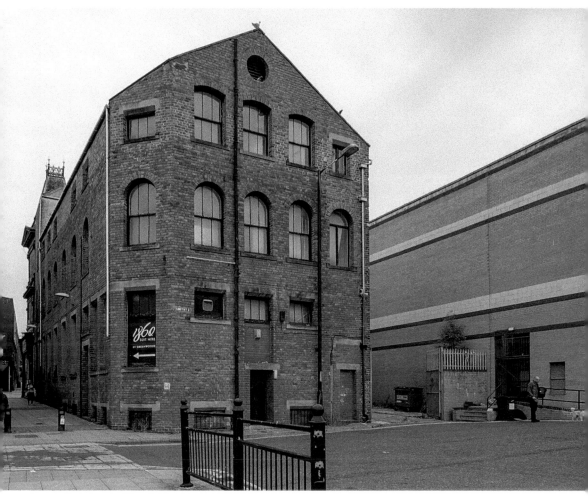

Rear view of Greenwoods.

27. National Westminster Bank

The National Provincial Bank, formed in 1833 in Newcastle, opened its first branch in South Shields in 1848. Whether this was at No. 40 King Street cannot be confirmed. However, the bank was listed at this address in Slater's Directory in 1854. The property also has a connection with the North of England Joint Stock. Situated at No. 35 Market Place, the organisation's manager, a Mr John Ridley, went on to become the manager of the National Provincial Bank in 1854. The rooms above the bank were the offices of Graham & Mabane Solicitors, Belle Vue Building Estate Co. Ltd and F. W. Purvis, house agents in 1909–10.

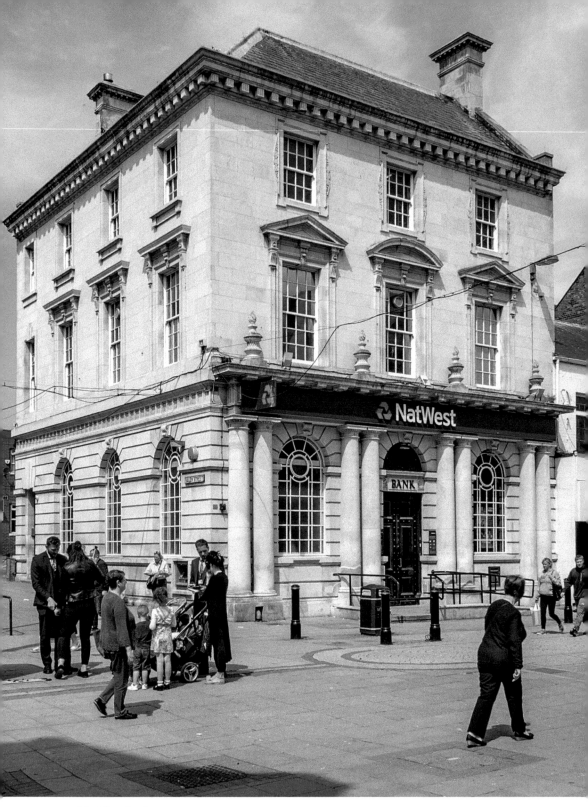

NatWest Bank.

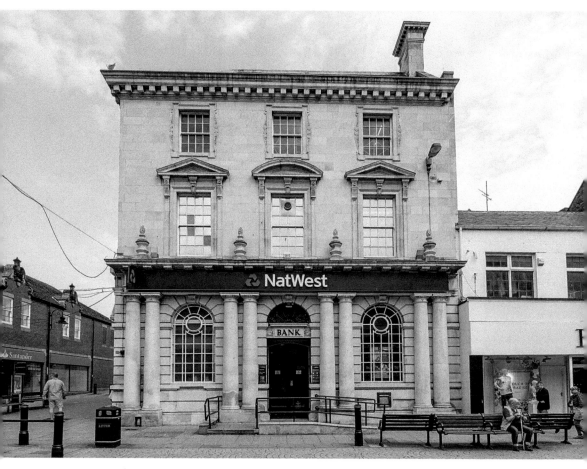

NatWest Bank.

28. The Bridge Inn

For generations this attractive art nouveau building was a focal point as what used to be the Bridge Inn. For several years in the nineteenth century it had the unusual distinction of also being the coaching station for railway passengers, who had to go through the hotel – then known as the Bridge Inn – to buy their tickets in a back room. They would then go on to the coal depot at the top of Salem Street (later the rear station yard) to climb onto a few carriages attached to empty coal trains going back to Washington, where they had to change trains.

Later in the Victorian era the inn achieved some notoriety for the arrest there of a culprit in a particularly gruesome murder in Morton Street, off Mile End Road. The pub eventually closed towards the end of the 1960s, together with the neighbouring jewellers shop, Alexander's. The white glazed tiles to the rear offshoot remain largely intact. These would have been used to reflect natural light into the back of the property.

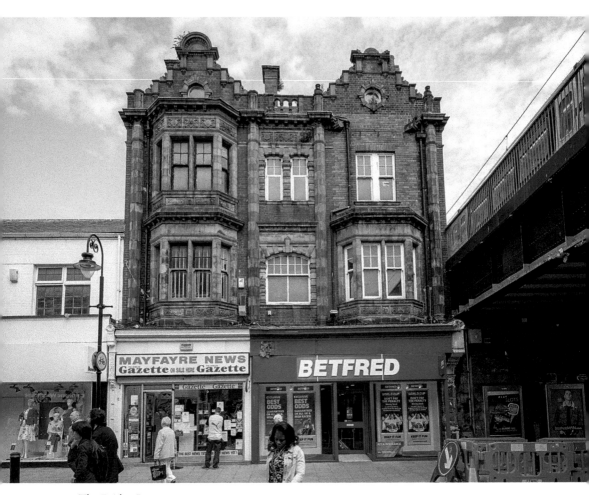

The Bridge Inn.

29. Edinburgh Buildings

This fabulously ornate building hides some secrets. It was originally a bakery, and the ovens still exist below pavement level, which, when they were built in the 1880s, were part of the Edinburgh Bakery, from which Edinburgh Buildings takes its name. The property was designed by Thomas Edward Davidson – look for his name, proud in the stonework. He had offices in Albany Chambers next to what was Binns but in the 1880s, he entered into partnership with Alexander Davidson Johnston, proprietor of the Edinburgh Bakery, which had a branch where the British Heart Foundation shop is now. The incentive for the venture seems to have been the relocation of the baker's from one side of King Street to the other. Thomas Edward Davidson also moved his architect's practice across from Albany Chambers. By the summer of 1887, the ground floor of Edinburgh Buildings

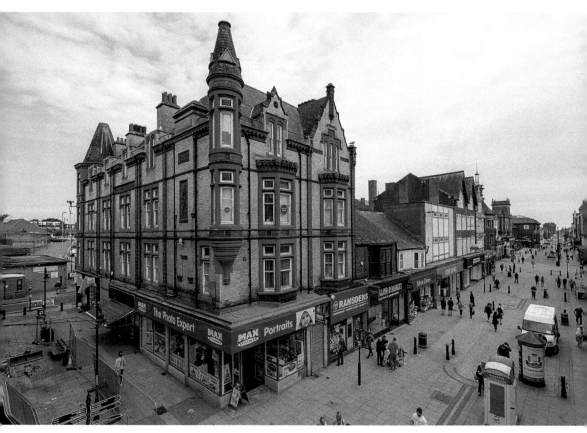

Edinburgh Buildings.

mainly comprised shops, with a total of more than twenty offices on the first and second floors, and a further ten in attic rooms above. Each landing had its own coal hole for keeping each office scuttle well filled. By the turn of the twentieth century, occupants of the offices included the South Shields Equitable Permanent Building Society, engineers W. Cory & Sons and also Alexander Johnston, who, by then, was listed as a property owner, the Edinburgh Bakery having by then gone out of business. Architect Thomas Edward Davidson had a go at local politics in later life, contesting the Westoe Ward, on a manifesto of sanitary reforms and temperance. He was unsuccessful in his attempts. He lived for a time in Salisbury Place and later in Harton Village.

30. The Scotia

This *c.* 1903 three-storey building was designed by architect Henry Grieves. It is of red brick, with ashlar dressings to the doors and windows and has a Welsh slate roof. It is in the style of Edwardian baroque with some nice art nouveau

embellishments. The small square tower to the right has a pyramidal roof with a fine spiked wrought-iron finial. This building is the best example of its type in South Shields and it is Grade II listed. In August 1904, the *Shields Gazette* informed us Grieves tendered 'Offers are invited for the counters, screens, gantries, seating et al, a schedule of which can be seen at the offices of Henry Grieves, Albany Chambers, South Shields'.

There were a lot of people outraged at the licence being granted for the Scotia. People thought that three public houses in that prominent position would increase the drunkedness in that area. However, some with their glasses half full retorted saying, 'When the Corporation have finally completed the job they have in hand, Shields will be proud of the fine area they have provided. What shall we call it – Piccadilly Circus! Why not?'

Some pubs took their names from actual vessels and it's thought that this is the case with the Scotia public house. The tug *Scotia* was owned by Councillor Joseph Lawson, which in 1884 set off from the Tyne for Scarborough, to bring back the hull of the tug, *Messenger*, when the *Scotia* developed a fault in one of her cylinders. An attempt was made to beach the tug but to no avail, so the *Scotia* was abandoned and it was left to the steam tug *Friends*, also of Shields, to tow the *Messenger* safely back to harbour. The next day the crew of the *Scotia* returned home aboard the brig *Wild Rose*.

The Scotia frontage.

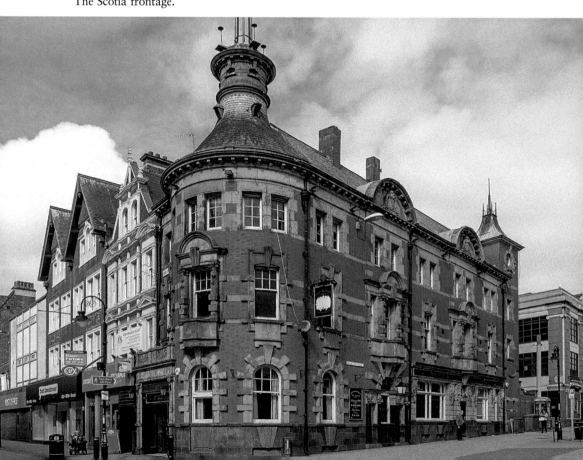

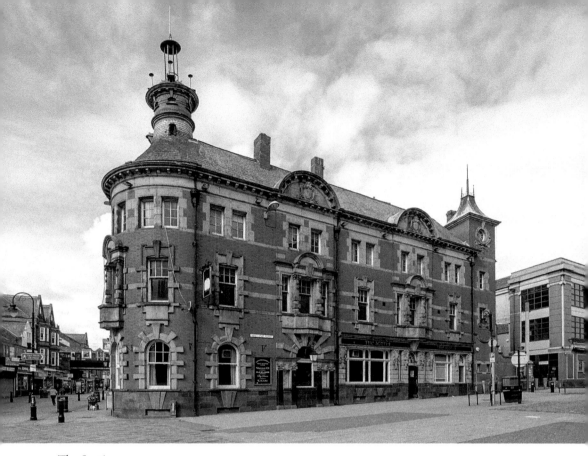

The Scotia.

Sadly the pub closed its doors in 1991 and architectural plans were drawn up for the building to be converted into a shopping arcade and offices. Thank goodness the plan fell through when no buyer could be found. Other plans for the building included Scottish and Newcastle extending the pub into the neighbouring Food Weigh House in King Street. Police said that converting the traditional pub into a bigger 'fun' pub aimed at the youth market would lead to trouble. I am happy to report that the Scotia is still open for business – cheers.

31. The Royal Assembly Hall

This fine piece of architecture started life as the Royal Assembly Hall and has had several changes of function and name over the years. The *Shields Gazette* recalls:

> There was a very large gathering yesterday, in response to invitations sent out by Mr Farquhar Laing, proprietor of the above hall, including dignitaries far and wide. Mr Laing said he had to thank all very sincerely for their presence there that afternoon, and for so heartily responding to his invitation to view the hall and premises, and hoped what they had seen would meet with their

approbation and they would look upon it as a fairly good adjunct to the public halls of the town. [Hear, hear] One of the largest halls in the district it will be suitable for theatrical entertainments, balls, bazaars, public meetings and concerts. The building is prominently situated in Stanhope Street at the rear of the Royal Hotel, with which it is connected by covered bridges and corridors. The principal elevation forms a handsome façade in the English Renaissance style of architecture. Normandy bricks and Hebburn stone dressings have been used in the exterior walls. The principal entrance is at the west end of Stanhope Street and it is very tastefully designed. The large entrance hall or crush room forms the first apartment. On either side are cloak rooms for ladies and gentlemen respectively. These rooms are all handsomely furnished in a first class manner. The hall is 121 feet long, 60 feet wide and 40 feet high. At the end nearest the entrance are the orchestra and platform, capable of accommodating around 250. This portion of the hall is semi-circular in shape and covered with a dome ceiling. The ceiling of the main hall is in the form of a barrel vault intercepted by semi-circular groins, springing from pilasters. All this interior decorative work is executed in fibrous plaster. This new material is unrivalled for the purpose and by far superior to the old method of lath and plaster work. Decorated in tints of cream, salmon, and gold the appearance of the hall is one

The Scala.

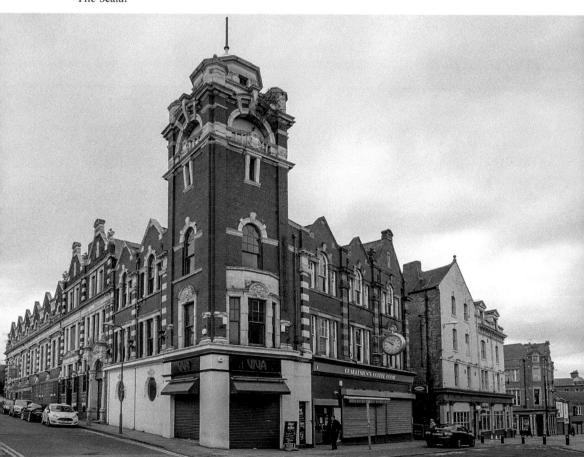

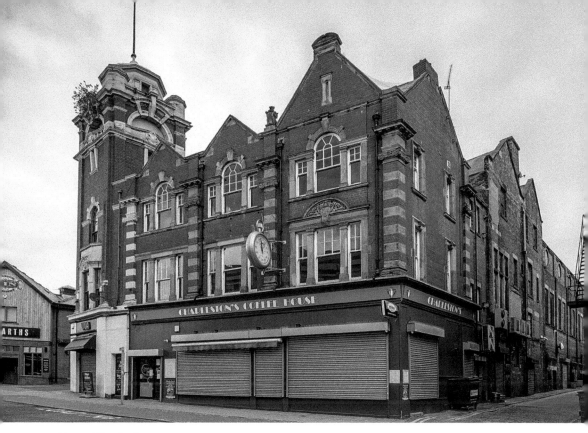

Above: The Scala.

Below: The Scala, Tinkersmiths.

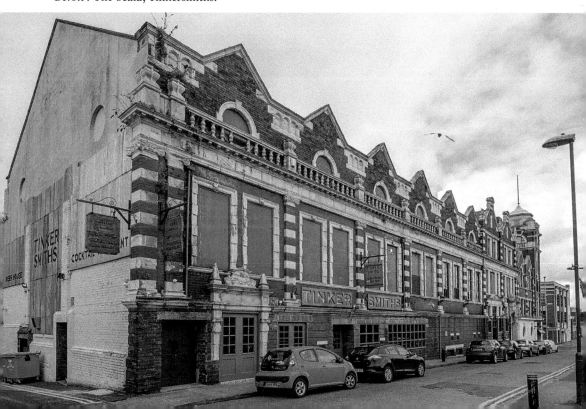

blaze of colour. The floor of the hall is laid with hardwood specially adapted for dancing. On occasions other than balls, however, the floor will be covered with a carpet in keeping with the other embellishments. Richly furnished couches and seats will occupy the remainder of the hall.

In recent years the rear of this fabulous building has been turned into a very stylish pub, Tinker Smiths. It is truly wonderful to see the old blending in with the new. A favourite feature for me is the wonderfully restored old theatre circle, which can be viewed from the bar area.

32. The Ship and Royal

Originally this was the Royal Commercial Hotel, then called just the Royal Hotel, and now the Ship and Royal. In the late nineteenth century, this establishment was taken over by Corbridge gentleman Farquahar Laing. He had ideas of grandeur and built a function room on waste ground to the rear of the hotel (the red-brick building adjoining to the left). The two were connected by overhead bridges and passages, the remains of which can still be seen today. Faint lines have been added to the image to show where these would have been. In August 1896, the *Shields Gazette* reported on a major refurbishment.

The Ship and Royal frontage.

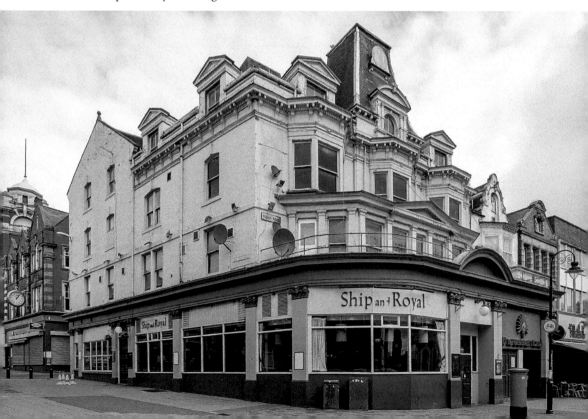

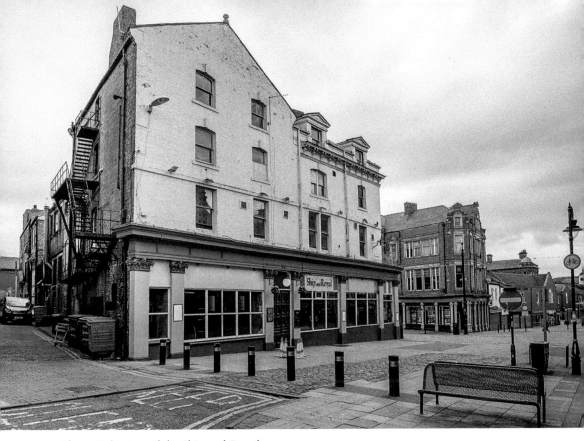

Above: Side view of the Ship and Royal.

Below: Imaginary lines where the two buildings would have connected.

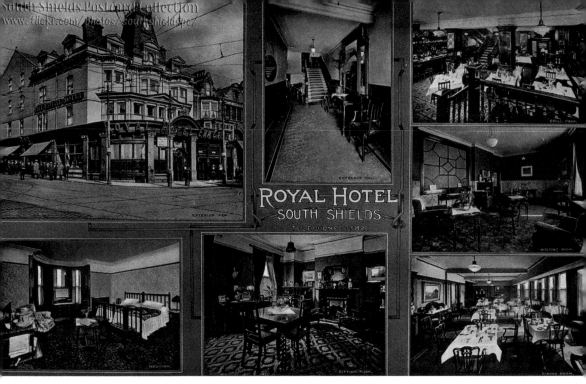

Postcard of the grand inside of the Royal Hotel.

This popular and well-appointed hotel has just undergone some important interior alterations and the whole of the rooms from top to bottom have been refurbished and redecorated. As is well known, the ground floor consists of a large grill room and refreshment bar. This has been beautified to no small degree and presents a much more cheerful appearance than it had hitherto. On the first floor are the dining room, buffet and billiard room and adjoining the latter is now a luxuriously furnished sitting room. The floors above have also received no small attention and everything possible seems to have been done with a view to the needs of a first class hotel, such as to be expected to exist in a flourishing town like South Shields. Messrs Laidler and Co of Northumberland Street, Newcastle were responsible for the decorations and Messrs Brash and Willan, South Shields, for carpeting and furnishing.

This postcard from my collection shows how sumptuous the hotel would have looked.

33. Stags Head

The Stags Head is a quirky terraced pub in the centre of South Shields. It has been hailed a national treasure, being named as one of the watering holes of greatest architectural interest in the UK. The pub is included in a Campaign for Real Ale (CAMRA) pub guide, called Britain's Best Real Heritage Pubs. Built of brick in 1897, the architect is still unknown. The pub has long been

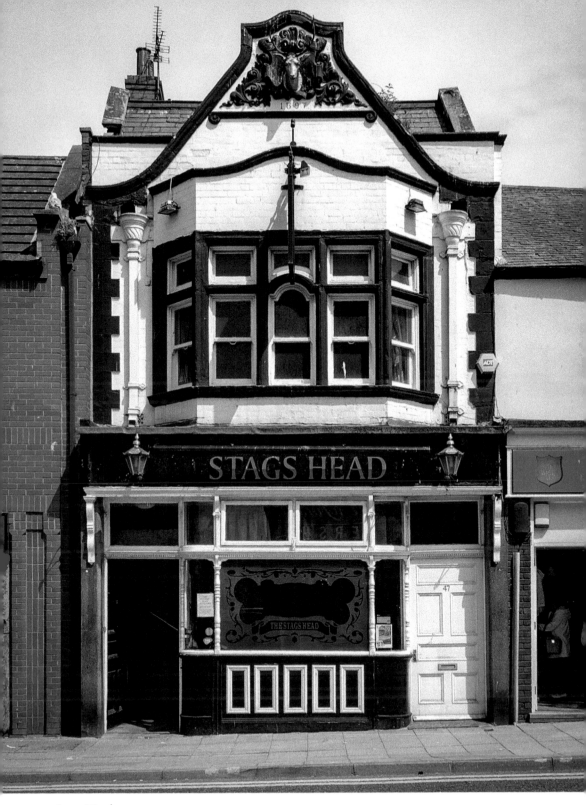

Stags Head.

noted for its original bar features, as well as for being one of the smallest pubs in South Shields. Two storeys in height, it sits under a Welsh slate roof with a brick chimney to the north. In the CAMRA inventory of historic pubs, the Stags Head is highlighted for boasting two original bars. Another striking feature is the entrance lobby, part of which includes floor to ceiling tiling in dark green, gold and brown, with diamond tiles in relief on the dado, as well as a tiled frieze at the top. The small public bar has an unusual feature of a wide four-centred arch that spans the downstairs server. Within it is the original bar back, topped by a modern clock and broken pediments and a bar counter that has been extended to continue around the corner, but closely matches the original work. The pub also features a large Victorian tiled fire surround, and who could miss the enormous stag's head above it. Pubs are a fundamental part of British life but a historic pub with an original interior is something rarer. The pub is also renowned for its cask ales and great pub atmosphere. The Grade II listed building has a very traditional look and feel to it and is reputedly one of the oldest in town. The main trading area is an open-plan bar and there is also a function room on the first floor, which can be used for events and private functions. Always a popular pub, it was up for sale in January 1893 for £2,000 and finally sold for £4,100, equivalent of £400,000 in today's money.

34. Riddicks Building

No. 22 Fowler Street is home to the fabulously ornate Riddicks building. Built as commercial and retail premises, it dates from the early twentieth century (around 1907–10). The architect of this beautiful building is unfortunately unknown. Its construction is of red brick with sandstone dressings under a gabled roof of Welsh slate. The ground floor of the building retains its original timber shopfront with narrow timber pilasters and detailing and a projecting cornice above. On the first floor there are a series of segmental headed windows with sandstone detailing. Above this is an area of former signage, which has been rendered. The second floor consists of further stone banding and segmentally headed windows set under a deep cornice. The gable end includes decorative stone detailing to Fowler Street, as opposed to Keppel Street, which is far plainer. The corner position of the building is strongly emphasised through the use of a projecting octagonal tower with curved pediments, circular windows and a lead dome. The author remembers this site being Hintons back in the 1970s. Many of the buildings around here are to be demolished as part of the South Shields 365 Vision, but thankfully No. 22 Fowler Street will remain as a building of significant architectural merit.

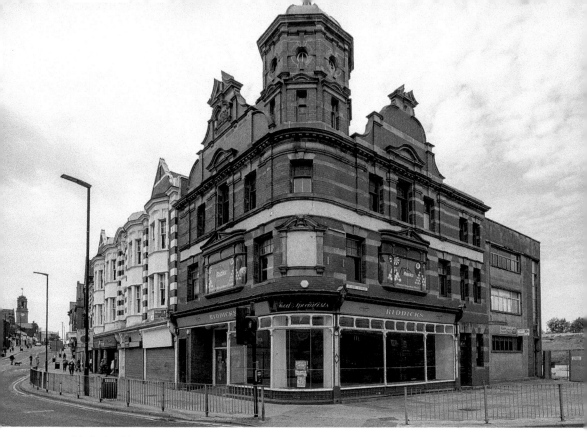

Riddicks building.

35. Barclays Bank

We know what a bank looks like: it is typically of solid construction with classical architectural features. The architecture is not merely about aesthetics, as banks are designed to convey strength, stability and security to would-be depositors. This magnificently curved building was the home of Messrs Dale Young & Co., bankers back in 1857. The North East Banking Company took it over in 1892 and after twenty-two years they amalgamated with the Bank of Liverpool. Later the Bank of Liverpool amalgamated into Martin's Bank in 1928. The King Street branch is one of the oldest Martin's branches to be in service as a branch of Barclays. With branches at Tyne Dock, Laygate, Harton and Westoe, Martin's certainly had the South Shields area fully covered.

Local architect J. H. Morton was the highly praised architect responsible for this three-storey and seven-bay impressive ashlar building. The ground floor is heavily rusticated above a high plain plinth and the central entrance and the door to Fowler Street have semicircular hooded openings with scrolled keystones. The first-floor windows have architraves and alternating triangular and segmental pediments. The second-floor windows also have moulded architraves and are

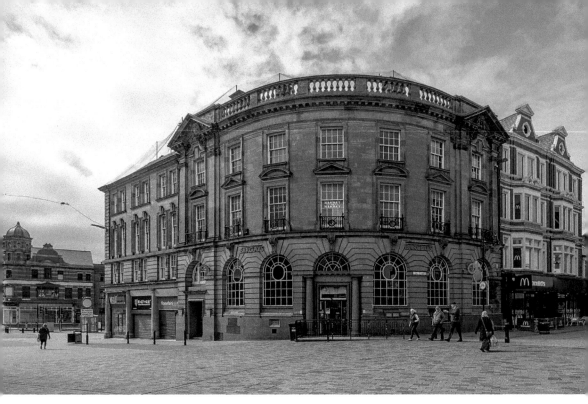

Above: Barclays Bank frontage.

Below: Side view of Barclays Bank.

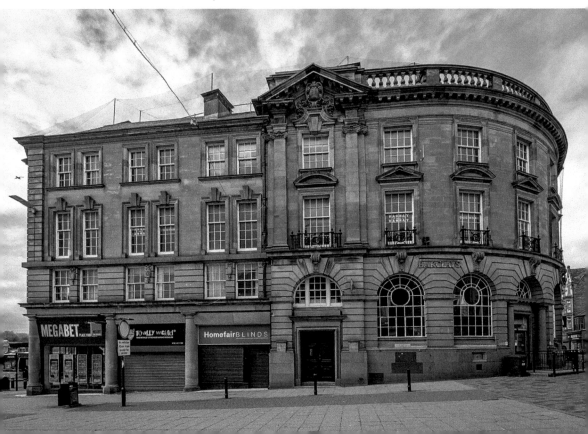

Rear view of Barclays Bank.

crowned by an entablature with a balustrade parapet. I wonder what the Victorians would have made of the strange cashpoint machines where one could obtain money from the bank by pressing buttons.

36. The Criterion

Originally the Criterion was built as a temperance hotel serving cocoa, which, in the 1800s, was the favoured drink of the temperance movement. It was called the Criterion Restaurant after the Criterion Grill in London, on which it fashioned itself, but by the 1870s it was serving alcohol as well as tea, coffee, soup, chops and tuppenny pies. Renovated in the late 1800s, the *Shields Gazette* reported:

> On Tuesday 28th July 1885, the Criterion Grill, another addition to the now numerous conveniences of the kind in South Shields, was opened to the public. The grill stands at the corner of Fowler Street and Ocean Road, commanding a view of these thoroughfares and of Mile End Road and King Street. Some months ago, Mr William Jackson of Sunderland, purchased the Criterion Restaurant

and called in the services of Mr Thomas A. Page, architect, to carry out the proposition to erect on the old site a building of more pretentious appearance and greater internal convenience than which was then standing. How effectually Mr Page has succeeded in his aim, and how handsome an addition has been made to the better class of the buildings in the town will be heartily recognised by anyone who cares to look around the grill. The endeavour was to establish a business as complete in its equipment as any of the metropolis or the chief provincial towns. On the ground floor of the building is a large bar and buffet, the two being entirely separate, and in a convenient quarter are placed lavatories. The staircase leading to the upper rooms is fitted with large mirrors and lit by a large two light stained glass windows, showing two appropriate scenes from 'The Merry Wives of Windsor' The grill room has been magnificently designed and its finished effect is almost beyond description. The walls are lined polished mahogany up to the height of nine feet – the dado being surmounted by mirrors and beyond this and below the cornice is a continuation of designs in Lincrusta. The ceiling is tinted in quiet tones of colouring, the enrichments being relieved in gold. The furnishings executed from Mr Page's designs have been carried out by Messrs Robson of Newcastle. The room is divided into five sections and the upholstering of each is done in Utrecht velvet. The far end of the room is fitted up with an elaborately fitted buffet, while near is the silver grill, the exterior of which is ornamented with hand painted tiles illustrating Shakespearean scenes. On the second floor a telephone is provided for visitors and near it are the smoke room and beautifully fitted private dining room with fireplace, over mantle and other furniture in the Adam style. The building is in the Queen Anne style and we may say that in its conception and completion reflects of the greatest credit upon Mr Page and the others engaged in the work, Messrs Robert Atkins & Co., of South Shields.

This excerpt from the *Shields Gazette* is in total contrast to the sad *Gazette* entry in 2012: 'A historic South Tyneside pub faces an uncertain future after being caught in a national chain's 3 billion pounds debt battle. Punch Taverns are selling The Criterion in South Shields, in a bid to cut operating costs and slash recent huge losses. It is one of 2,600 leased premises the Burton upon Trent-based chain is desperately trying to off load. Industry experts say it is likely to remain a licensed premises and may even flourish. But they warn the outlet could also be converted into a café or restaurant. Punch taverns which bought the pub in 2007 said it hoped to continue to trade as a "boozer".' Sadly it was not to be and Ladbrokes spent £200,000 converting the Criterion into a betting shop. In July 2018 the *Shields Gazette* reported that there were plans afoot to open the three upper floors of the building above Ladbrokes. A couple of local entrepreneurs have a twenty-year lease for the landmark site and plan to have the first floor up and running as a bar serving food by the end of 2018. A six room bed and breakfast establishment for floors two and three is sure to follow, and will be another asset for the town.

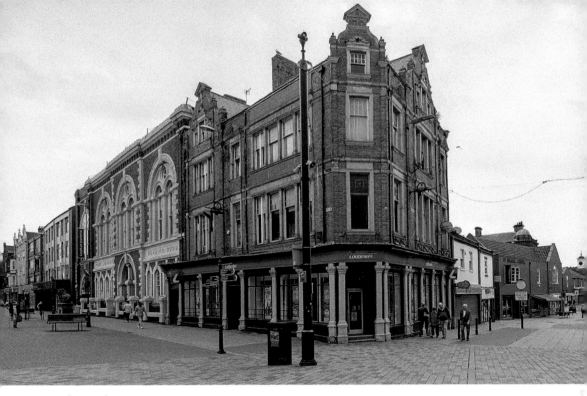

Above: The Criterion.

Below: Side view of the Criterion.

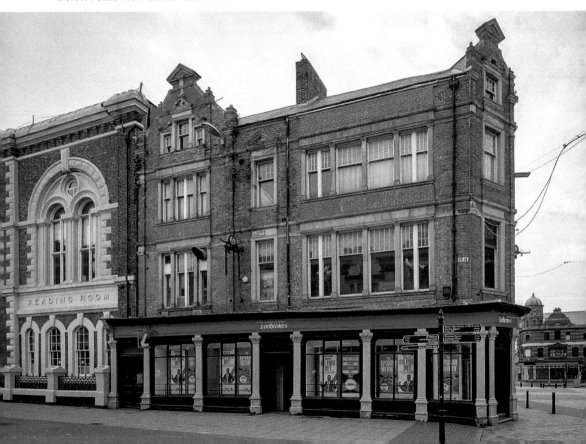

37. The Museum and Art Gallery

At the very heart of its community, South Shields Museum celebrates the rich heritage of South Tyneside and the people who shaped it. The building that South Shields Museum currently occupies has had a long and interesting past. It was constructed in 1860 as a home for the South Shields Literary, Mechanical and Scientific Institution. In 1873 the building became the town's first free public library and reading rooms and it opened as a museum in 1876. The museum is spread over two floors and tells the story of the borough's social, industrial and maritime history from 4,000 years ago to the present day through a range of displays, exhibitions and nationally significant works of art. It is hard to ignore the beautiful stained-glass windows on the half landing.

The centre window contains glass from Holy Trinity Church, South Shields. The top panel represents the miracle of giving sight to the blind and the two below show the parables of the Sower and of the Good Samaritan. They date from the early twentieth century and were the work of Messrs Clayton and Bell of London. The window to the left depicts St Luke and to the right St John is represented. These two splendid windows were originally in the west wall of the nave in St Andrew's Church in Hebburn. They were erected in memory of shipbuilder Andrew Leslie by his sister Mrs Stephen.

There is also Creature Corner, home to resident reptiles and insects, a busy tourist and bookshop and a small café, the Victorian Pantry, serving a range of hot and cold refreshments.

South Shields Museum and Art Gallery.

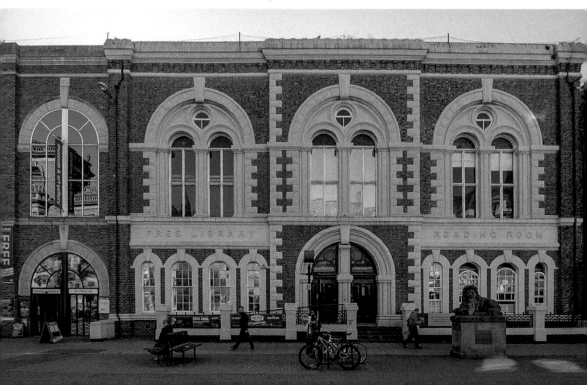

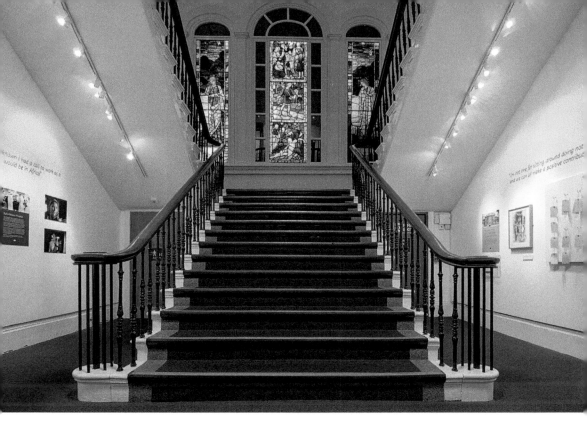

Central staircase of South Shields Museum and Art Gallery.

38. Kirkpatrick's

Architects T. A. Page & Son designed the Marine School, one of the grandest buildings in the town. It is built in the Elizabethan style with the central entrance on Ocean Road. It has a grand stone entrance with a pair of Tuscan columns. The two-storey, three-bay, square plan works well and all corners are marked with rusticated quoins. The bay at the south corner is carried up one full storey above roof level to form a square tower crowned by an entablature and pierced balustrade. It is lit by a semicircular headed window in each face. It originally had an observatory on top but this was removed in 1979 before the building was refurbished.

On 12 January, 1869, the new Marine School was ready for the formal opening ceremony and even critics of the project had to concede that it was a magnificent building the town could be proud of. The event was covered nationally and made an appearance in *The Times, The Pall Mall Gazette* and the *Shipping and Mercantile Gazette*. A large crowd of onlookers watched as the building was declared open by the Bishop of Durham. A description of the building appeared in the *Shields Daily News*. In addition to a spacious hall and a boardroom for the governors, there was a schoolroom furnished with forms and desks for seventy students.

On the second floor there was accommodation for the housekeeper and in the dome on the roof was the nautical observatory. This last feature of the building

was truly outstanding, housing a huge telescope that enabled students to practice the inspiring art of astronomy. Mr John Martin provided the telescope at a cost of £127 (today's equivalent of £2,300).

The first day's entries in the register in April 1869 numbered four were Robert Kerr, John Stott Stephenson, John Hutchinson and John Stratford.

The Marine School was replaced by the new Marine and Technical College at Westoe in 1964. The old Marine School building now plays host to the Stoneygate Pub Company and is known as Kirkpatrick's. The statue outside the pub is dedicated to a very brave local man who served in the First World War. John Simpson Kirkpatrick was a soldier throughout the war and his bravery was recognised by the fact he was twice recommended for the Victoria Cross and also for the Military Cross. He was renowned for using his donkey 'Duffy' to bring back soldiers from no man's land so they could receive treatment for their injuries. He was a remarkably brave man who is said to have brought back more than 300 injured soldiers.

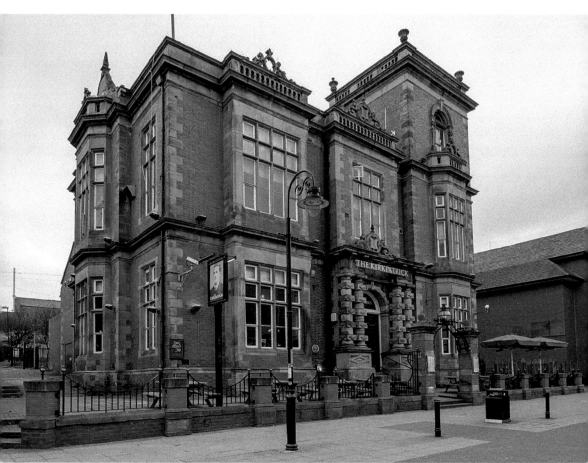

Kirkpatrick's, which used to be the Marine School.

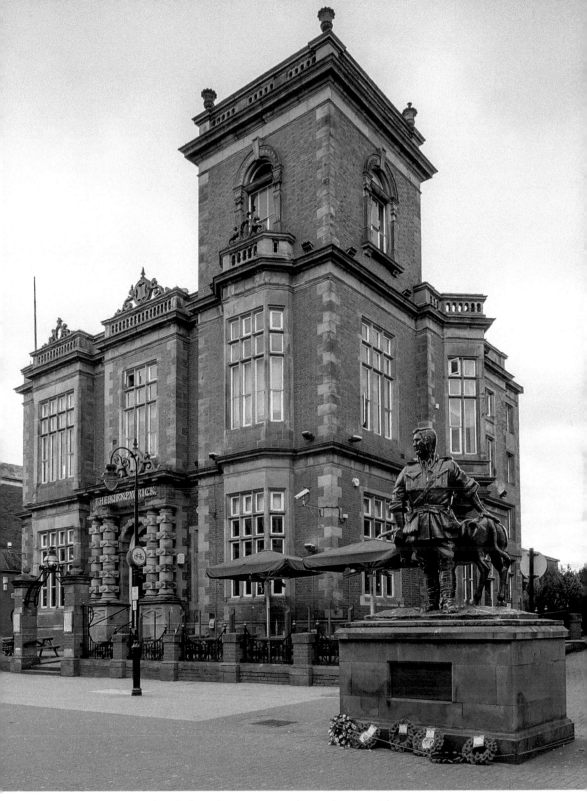

Old Marine School with the John Simpson Kirkpatrick memorial.

39. Arbeia Roman Fort

Arbeia was a large fort in South Shields, which is now a ruin that has been partially reconstructed. It was first excavated in the 1870s and the streets and school buildings on the site were cleared in the 1970s. A Roman gatehouse, barracks and commanding officer's house have been reconstructed on their original foundations. The gatehouse holds many displays related to the history of the fort, and its upper levels provide an overview of the archaeological site.

The fort stands on the Lawe Top, overlooking the River Tyne. Founded around AD 120, it later became the maritime supply fort for Hadrian's Wall and contains the only permanent stone-built granaries yet found in Britain. It was occupied until the Romans left Britain in the fifth century. A possible meaning for 'Arbeia' is 'Fort of the Arab Troops', referring to the fact that part of its garrison at one time was a squadron of Mesopotamian sailors from the Tigris. From archaeological evidence it is known that a squadron of Spanish cavalry was stationed there. It was common for forts to be manned by units originally from elsewhere in the empire, though often enough these would integrate and end up by recruiting locally.

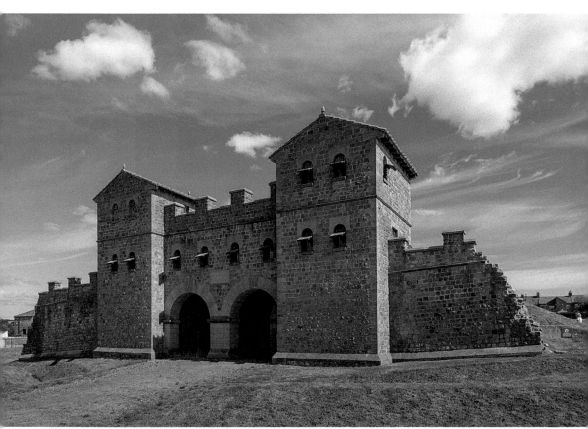

Front elevation of the Roman fort Arbeia.

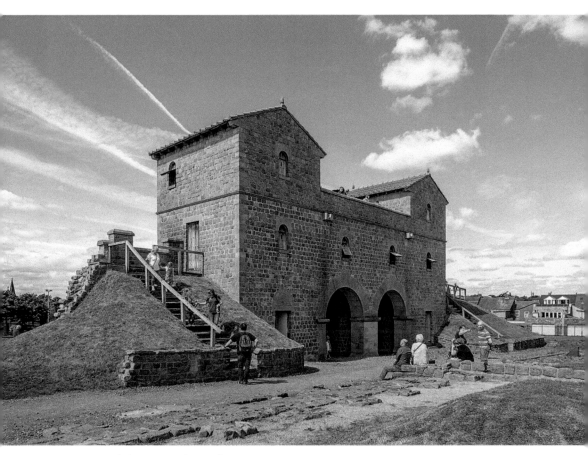

Rear view of the Roman fort Arbeia.

40. Pilot Office

Boasting a superbly elevated position overlooking the Tyne, Wellesley Court, as it is known, is a Grade II listed building dating back to 1840. The building was used as the Pilot Office between 1869 and 1980, when it was converted to fabulous residential apartments. The Tyne Pilots were very competitive as they got paid handsomely for going out of the river mouth, even before the piers were built, and bringing ships safely into the river. Tyne Pilots of the latter half of the nineteenth century were the real aristocracy of the river's workforce. These men could really afford to dress well and long kept their distinctive 'stove pipe' hats. The house reception was recently open to the public as part of 'Heritage Open Days'. The official seal of the board was designed by Mr Leitch of North Shields, and depicted the Tynemouth Lighthouse with a ship in full sail and a pilot boat in the foreground, and is dated 1865. The circular glass window depicts the seal.

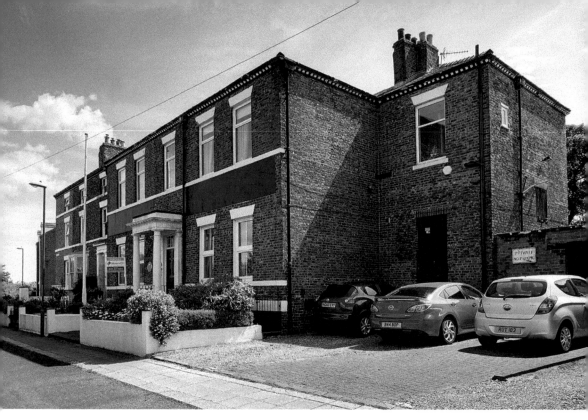

Above: Pilot House frontage.

Below: An unusual rear view of Pilot House.

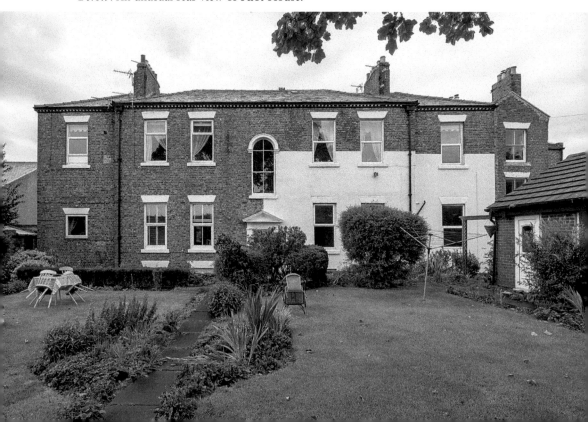

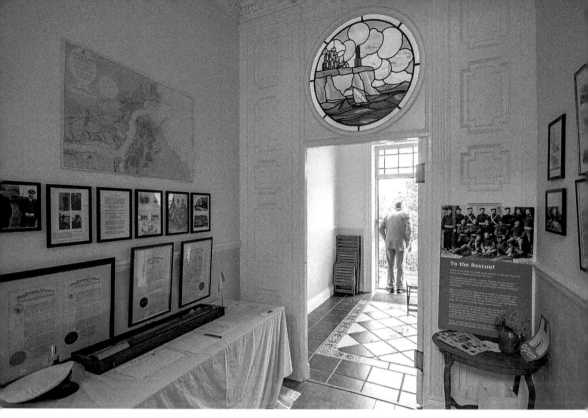

Hallway of Pilot House.

41. Pilot Watch House

The original Pilot Watch House for the use of South Shields pilots was completed in March 1890. It stands perched near the top of the embankment on the Lawe, within a few yards of the 'old beacon', giving a fabulous full view of the harbour entrance and beyond. Designed by local architect Mr J. H. Morton, it consisted of a room on the ground floor measuring 30 feet by 20 feet and a smaller room above measuring just 26 feet by 10 feet. The upper room housed a large telescope, a gift from Mr Salmon. The telescope sat on a round table and offered great views from the projecting bay window. In the centre of the downstairs room there were seats and tables and a stove for heating the place, the pipe for which passed up through the middle of the upper room. The upper floor was rebuilt in 1930 and specially shaped windows at the north-east and south-east corners allowed clear views over the sea.

Outside there is a veranda, which would afford plenty of shelter for pilots viewing in inclement weather. The structure is enclosed by neat railings and the building is of red pressed brick and the roof is covered with slates of a unique design.

In recent years it has stood empty after the retirement of the last two Tyne pilots, John Marshall and Alan Purvis. The watch house would have been great

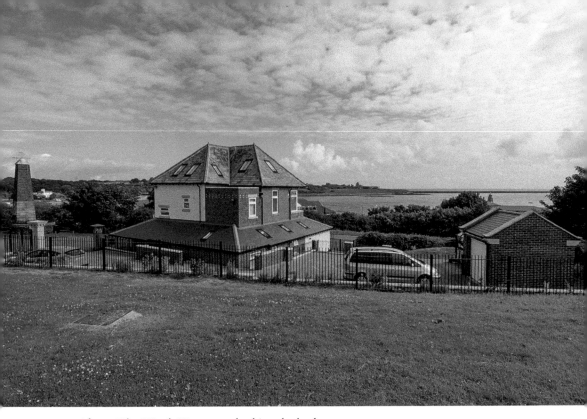

Above: Pilot Watch House overlooking the harbour.

Below: Pilot Watch House frontage.

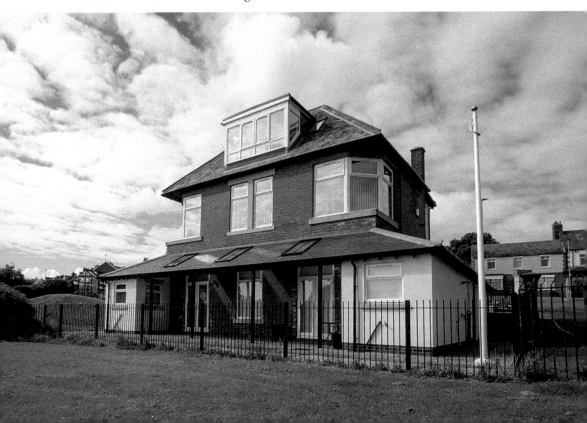

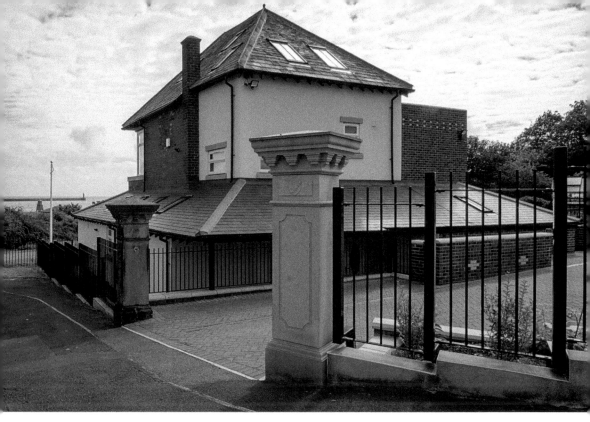

Rear view of Pilot Watch House.

as a small maritime museum. It would have benefitted the town and could have housed some pilot memorabilia (remaining pieces of the Protector, which was blown up by a mine in 1916, for example). It could have also housed photographs and paintings and pilot record books. This was no to be...

In March 2012 the three-storey property went up for auction at Newcastle's Marriott Hotel. It was marketed by Andrew Craig estate agents with a reserved asking price of £69,950. Remarkably it was purchased by a private buyer for a staggering £245,000. The dilapidated property was set to be invested in and converted into a family home. At the moment Nos 118–120 Lawe Road are a pair of two-bedroom rental apartments.

42. North Marine Park Lodge

John Peebles was head gardener for the Marine Parks over a hundred years ago. He would have been delighted that the park is due to be returned to her original splendour. When John was promoted to head gardener, he and his family moved to the lodge. Before rising up the ranks, he lived at No. 14 Salmon Street, just off Ocean Road. He provided for his wife Alice and four children, Annie, Constance, John and Violet. Alice's mother had been widowed and lived with the Peebles family too. Many people may have never seen the lodge, as it is quite well hidden

behind trees and shrubs. The substantial building is of red brick with a hipped Welsh slate roof. The sash windows seem to have been lovingly restored and there appears to be a terracotta theme; there is a striking terracotta dado around the lodge, together with a terracotta plaque on the wall, facing Lawe Road. Chrysanthemums may be the link from the plaque to the seating in South Marine Park and the detailing on the restored bandstand and also the detailing on the lifeboat memorial. The brickwork arch above the first-storey twin windows is an interesting feature. On closer inspection the arch consists of terracotta tiles that have a mixture of fig leaves and fig detailing.

The park has just been given £2.4 million of National Lottery funding and plans are available to look at the proposals. It will be in keeping with the original Victorian park. Its new design will make better links between the new promenade, the parks and the Lawe top and really open up the whole area.

The plans also include restoring original features such as the stone grotto and the promenade staircase as well as introducing new features including play areas. Improvements to lighting, seating and the bowling area are also planned, as well as special art installations. It is expected that work will start late in 2018.

The lodge, North Marine Park.

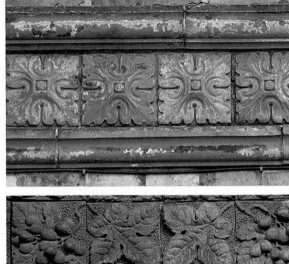

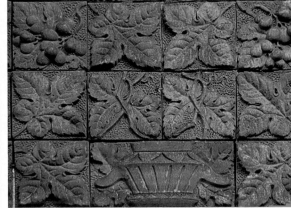

Terracotta detailing on the lodge.

43. Pier Pavilion

The Pier Pavilion started out as a rain shelter. The South Shields Corporation, at the instigation of Alderman Gompertz, converted the old seaside shelter in Pier Parade into a small community theatre in 1948. It was said to mitigate the loss of the Queen's Theatre in Mile End Road, which had been destroyed by bombing in 1941. The Pier Pavilion was opened on Whit Monday 1949 and for the next few years presented seasons of repertory and concert shows. Before 1950 the society had rehearsed in the Dorset Café in Ocean Road and the Havelock Inn. No. 21 Beach Road was purchased as a headquarters and was renamed Westovian House in 1950. In January 1977 the Westovians took a twenty-one-year lease on the Pier Pavillion and installed a fire curtain, a licence was granted and it was all good to go. The theatre has since been through many changes, including full modernisation with the addition of a licenced bar and coffee bar. Internally, the original old cast-iron columns and fretted iron arch spandrels give touches of visual delight and Victorian character. The theatre has a sloped 292-seat auditorium with plush red 1930s tip-up seats that are contained between a run of cast-iron columns either side of the auditorium.

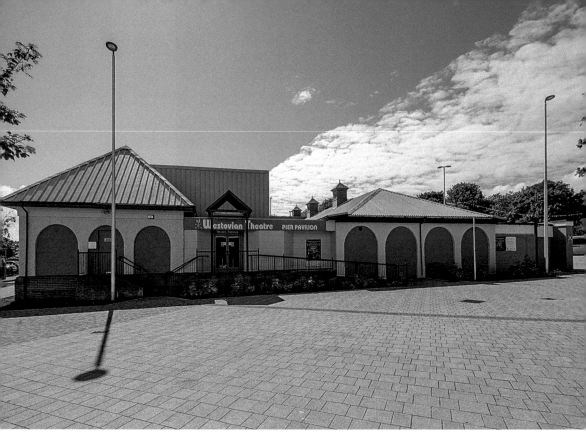

Above and below: Pier Pavilion, home to the Westovians.

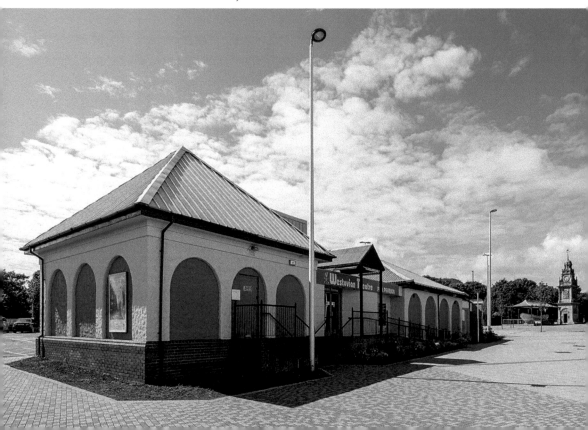

Pier Pavilion, detail of the original shelter.

44. Haven Point

Haven Point is a shining example of regeneration in South Shields. Its location on the seafront is almost exactly where the Victoria seawater baths would have been. These seawater baths were most popular in the 1900s. Bathing in seawater and natural salt solutions has a long history. Almost 500 years before the birth of Christ, Hippocrates, known as the father of medicine, noticed fishermen who had injured their hands soaking them in seawater. They seemed to have few infections or complications and he encouraged his patients to bathe in warmed seawater.

South Tyneside Council appointed LA Architects to design a state-of-the-art pool and leisure complex after the closure of Temple Park Centre, which was much further out of town. As designs developed, the opportunity to include other facilities arose, including an outdoor grassed amphitheatre, terraces for events and exhibitions, and a sunbathing area, which are all available to the public. The facilities include an eight-lane 25-metre pool, a teaching pool, leisure waters, fitness suites, studios, multipurpose rooms and a bright café-restaurant.

The 15-metre-high atrium is the ideal place to show off a sculptural piece called the' Wavemaker'. Based on the form of Olympic medal winner Mark Foster, it features a 6 foot 6 inch wire mesh swimmer in motion. Butterfly stroke in all of its stages glides across the length of the building. Michelle Castles was the much acclaimed artist commissioned for the piece. HRH the Duke of Cambridge was greeted by huge crowds when he opened the venue in November 2007.

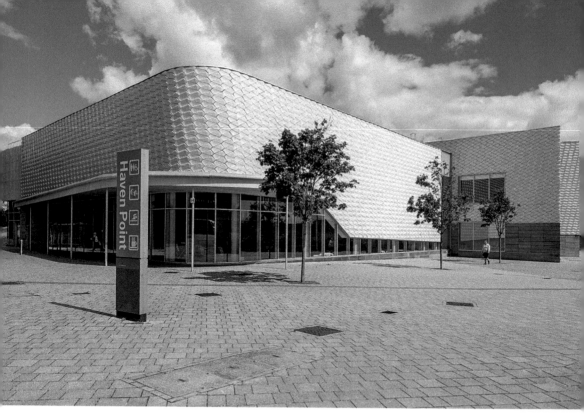

Above: Haven Point.

Below: Side view of Haven Point.

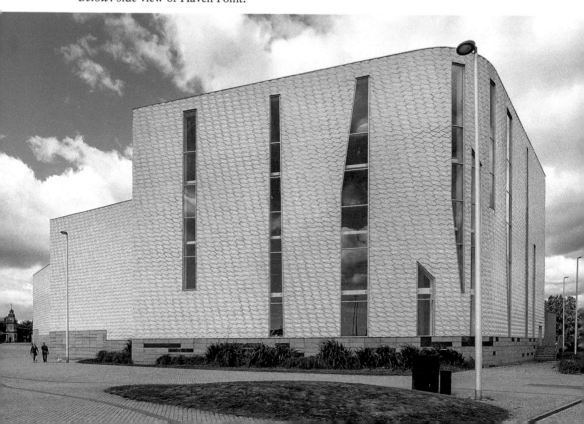

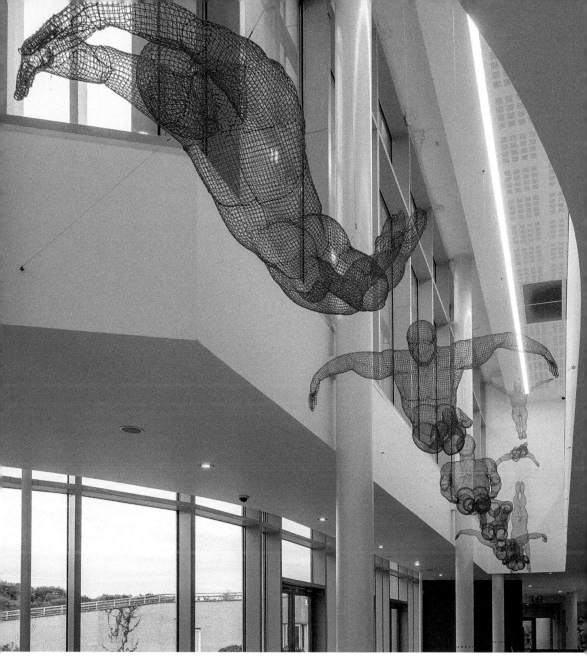

The Wavemaker sculpture.

45. South Shields Volunteer Life Brigade

In 2016, South Shields Volunteer Life Brigade was awarded the Freedom of the Borough of South Tyneside in recognition of its remarkable record of over 150 years of service since its formation in 1866. This Grade II listed building is of enormous architectural and historic interest with its watchtower, wooden spiral

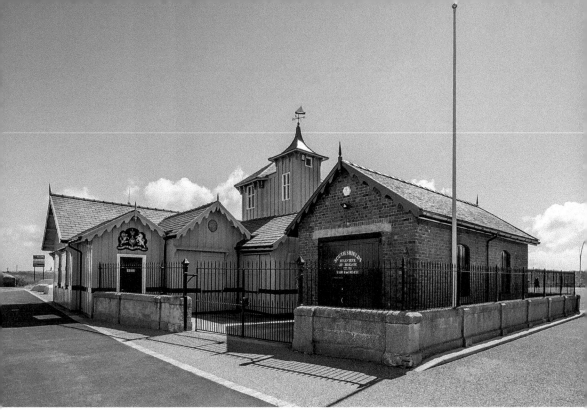

Above: South Shields Voluntary Life Brigade House.

Below: Rear view of South Shields Voluntary Life Brigade House.

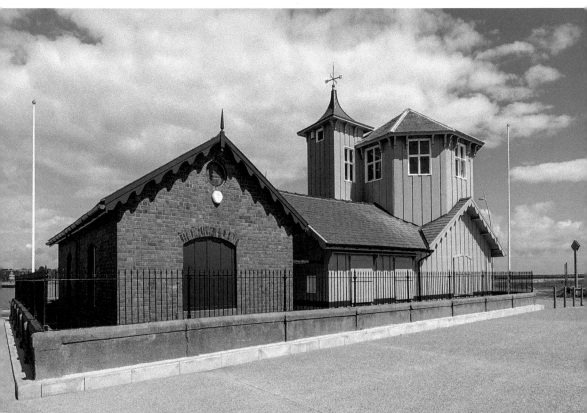

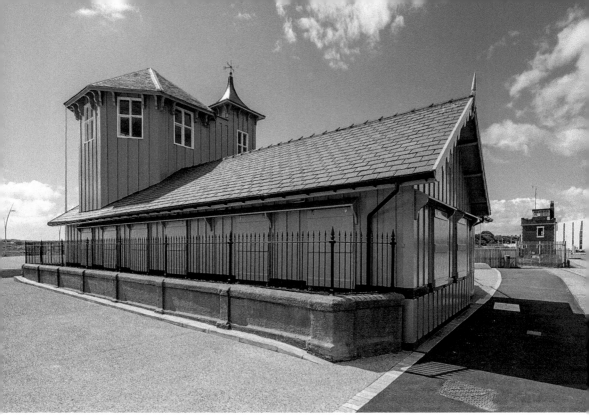

Side view of South Shields Voluntary Life Brigade House.

staircase and adjoining coast rescue equipment building. It is probably one of the oldest surviving all-wooden, mid-Victorian buildings in Britain. The watch house has a fascinating collection of artefacts, photographs, paintings, records and equipment from its origins in 1866 to the present day. Significant items include a full set of the original breeches buoy rescue equipment, figureheads from shipwrecks, a variety of name boards and wooden decorative carvings from ships. The building also houses modern-day rescue equipment and is well worthy of a visit. Some amazing local paintings are housed there including *Gypsies Camped on Beac'* by Ralph Hedley, *Going to the Wreck* by Joseph 'putty' Garbutt and the famous *Opening of the Albert Edward Dock* by Duncan Fraser McLea.

46. Master Mariners' Cottages

Master Mariners' Cottages is a small compact area of approximately 1 hectare. The area comprises a remarkably intact group of early Victorian almshouses. It is a fascinating collection of buildings that illustrate the wealth of and respect for the seafaring community. The two neat single-storey terraces and the gardens they enclose are full of character and form an unusual historic enclave among the more regular terraced surroundings. Each terrace of cottages and the two sets of garden boundary treatments are separately listed Grade II.

Above and below: Master Mariners' Cottages.

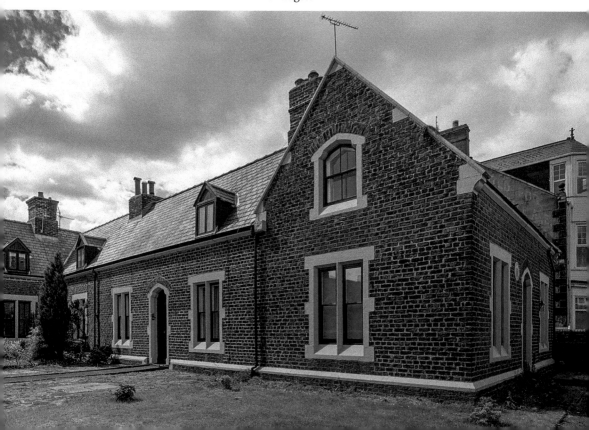

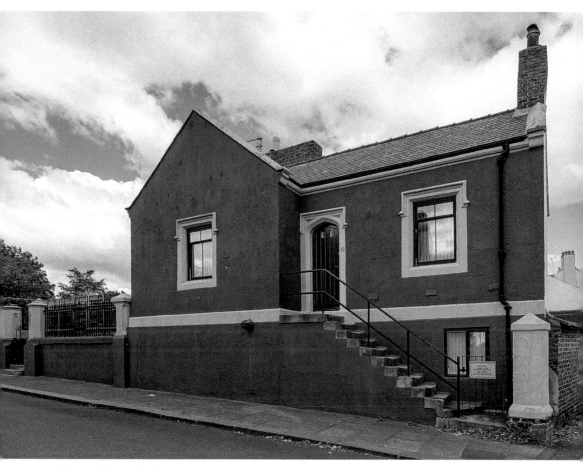

Master Mariners' Cottages.

The entire conservation area comprises two semi-formal, three-sided terraces of twenty-two and seventeen brick cottages respectively, which face each other across enclosed green courtyards. These are part communal and part private gardens, the boundary walls of which have railings, pillars and gates. A length of Broughton Road splits the area into two halves. With the exception of the north-west end unit, the other three end terraces face the public road. The origins of the larger single unit on the north side, which does face outwards, suggest it was originally the communal library provided by the originating society and was therefore accessed from outside the courtyard. Due to the failing health of the long-serving librarian, the committee decided to convert the library into a two-room cottage. All books, maps and full rigged model ship from there were given to our museum. The largely single-storey terraces were each individually listed in 1983. Each terrace is of a similar basic building style but not identical and between them they exhibit early and mid-Victorian architectural characteristics.

47. Colman's Seafood Temple

What a fantastic transformation, from the 1930s bandstand and public conveniences to the fabulous 'Colman's Seafood Temple'. Unfortunately, 'Ghandi's Temple', as it is known locally, has no connection with Mahatma Ghandi, the historical figure. I like to think of it as foreign jewel washed up on the sands. The building was originally constructed in 1931 and officially opened on Saturday 19 September that year. Almost no change has occurred to the building throughout its life, and it stands today encased in the 'Seafood Temple'. It is considered a Locally Significant Heritage Asset and appears on South Tyneside's Local List. Of note are the pink cast concrete kerbs and low art deco columns, which are part of the landscaping surrounding the building today and appear to be original, reflecting the use of cast concrete in the building itself. After more than £1 million investment, nine months of building work and much anticipation, 'Colman's Seafood Temple' opened its doors on Friday 26 May 2017. The idea was that of Richard Ord and his fish 'n' chips have been part of our town for generations. Richard and his family felt strongly about retaining the history of the structure and it was years in the planning. While underway the builders are said to have thought it would have been easier to knock it down and start again. Not being what the owners wanted, they decided to invest more so it could remain for future generations. The restaurant is very lucky to have nature's larder on its doorstep. Seafood arrives daily: lobsters caught at Marsden and Whitburn, oysters from Lindisfarne and fresh fish from North Shields.

Colman's Seafood Temple.

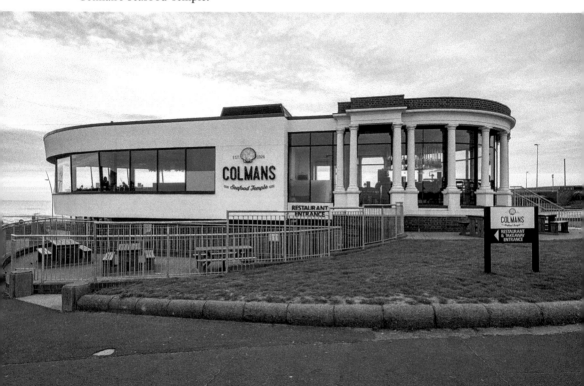

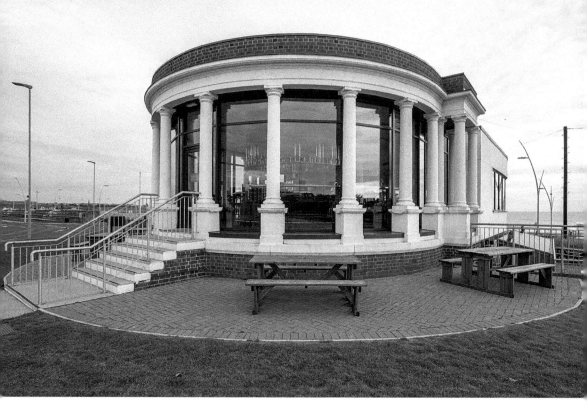

Colman's Seafood Temple.

48. The Marsden Inn

Overleaf we can see the Marsden Inn in all of her glory. Her mock-Tudor beams and pseudo heraldry make for an unusual exterior to this local watering hole.

The present pub may have been a local landmark for only seventy-five years or so, but the provenance of the name of the Marsden Inn in Shields is much longer and interesting. The original Marsden Inn was located south of the present pub, at the corner of Lizard Lane and Redwell Lane. The first licensee was a Jean Henderson, who was a widow when she died in 1859. The second lisensee was Nancy Swan, who was aged fifty and also a widow when she appeared in the 1871 census. The third licensee, according to the 1881 census, was Sidney Milne Hawkes, who also had the Marsden Grotto in the 1870s. Hawkes was followed by John Hopper, who, going by the census of 1891, was a single man of only twenty-one. He ran the pub with the help of his brother Thomas. Not long after, in 1896, this original inn was pulled down and replaced by a terrace of houses. This second pub was replaced, in turn, with the present Marsden Inn, built on the corner of what was described as Marsden Back Lane and Prince Edward Road East in 1938. Today the inn has nine beautiful en-suite rooms that have been refurbished, offering comfortable accommodation whether travelling for business or pleasure.

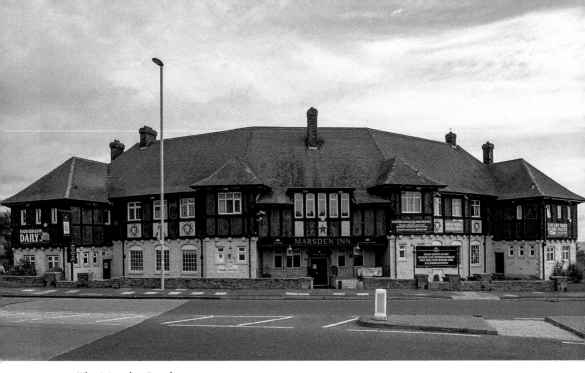

The Marsden Inn frontage.

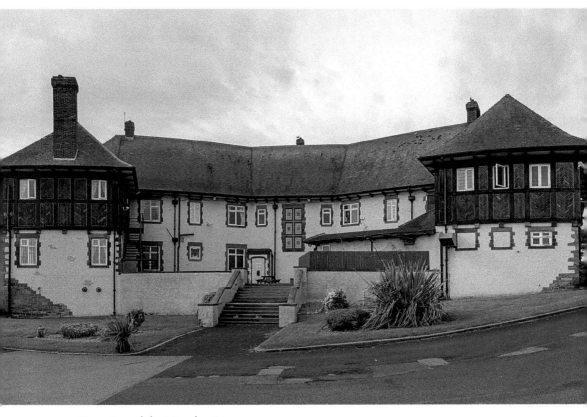

Rear view of the Marsden Inn.

49. Marsden Grotto

The fabulous Grotto cave bar is a major tourist magnet, a product of human eccentricity and hard graft. The first person to have made his home in the caves and the Grotto was Allenheads' miner, 'Jack the Blaster'. In 1782, Jack who was employed at the nearby quarry found convenient cave accommodation for himself and his wife. He was succeeded by Peter Allan, the son of gamekeeper to Whitburn nobleman Sir Hedworth Williamson. Peter considerably enlarged the caverns, creating living space, a bar and a ballroom. Here he would provide afternoon teas for people who would come on summer days to enjoy the outstanding scenery. Peter also drove a shaft through the roof of one of the larger caves, by means of which provisions could be lowered down to the house. Long after Peter had gone – he died in 1850 – a goods' hoist was the only means of getting beer and other goods down to what had become, by this century, a well-established public house. Remains of this contraption can be seen looking over

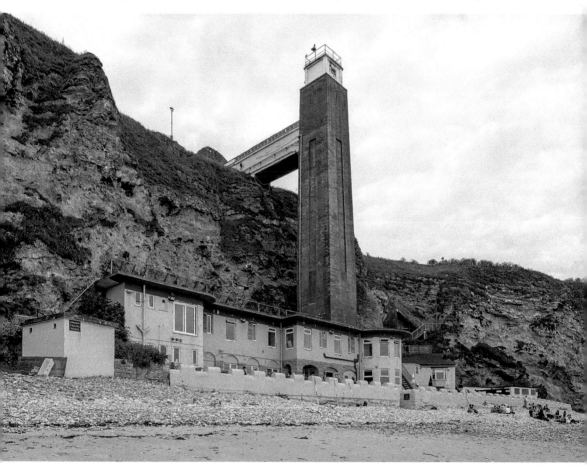

Marsden Grotto.

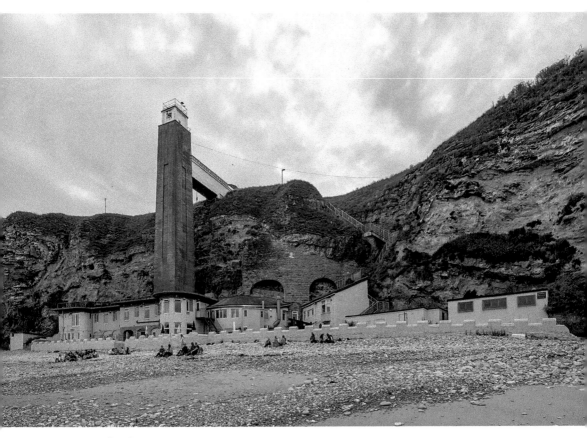

Marsden Grotto.

the cliffs in the car park. When modernisation plans, including the installation of an electric lift, were announced in 1936, they came as a great relief to the public who, themselves, had previously faced negotiating the steep, tortuous steps up and down the cliff face – all 119 of them. Promoters of the scheme, though, first had to convince the borough engineer John Reid of its safety. The modernisation, which heralded the addition of the lift, was the work of Vaux Breweries who bought the Grotto in the mid-1930s.

At the time of writing, a £500,000 transformation of historic Marsden Grotto is taking place. The owner plans to transform its unusual first floor into a suite of ten bedrooms. Planners gave the scheme the go ahead despite initial concerns about the impact on its ecologically sensitive surroundings.

The owner bought the Grotto at Easter 2017. In that time the venue's ground floor has been transformed into an exclusive seafood restaurant and maintained its popular cave bar. Plans include ten exquisite cave feature bedrooms, each with a fabulous view over Marsden Bay and the legendary Marsden Rock. In recent times the Grotto has made the grade in the Sunday Times Travel Guide as one of twenty best beachside bars in the UK. We always knew it.

50. Souter Lighthouse

It is hard to believe that Souter Lighthouse was the first in the world to be powered by electricity. In 1858 Michael Faraday instructed Fredrick Holmes to install his carbon arc lamp in the tower. Such was the success of the lighthouse being electrified that Trinity House saw that electricity could possibly be the way forward for all its lighthouses. Souter was built to ward vessels off the Marsden coast and the dangerous underwater reef known as Whitburn Steel. In the nineteenth century traffic on the seas became increasingly busy. All kinds of vessels plied their trade including bulk cargoes of coal and iron and large fishing fleets from local ports.

On 16 November 1866, the local ship *Sovereign* floundered on Whitburn Steel and struck the mighty Marsden Rock. Her crew of eleven all survived by scrambling back to the shore. This loss together with a dozen or more fatal shipwrecks in the same area called for something to be done. As an improvement for navigation, Trinity House decided on a new lighthouse at Lizard Point, Marsden. This new lighthouse could be seen for miles around with its 76 feet red and white tower.

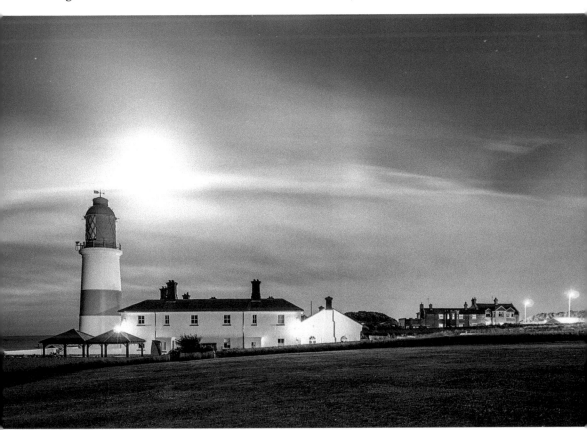

Souter Lighthouse.

This banded tower was designed by James Douglass, chief engineer in the borough. Robert Allison constructed the tower and the outlying structures from rubble masonry and encased it in Portland cement to protect it from the harsh elements. Buildings around the tower were designed in a courtyard manner and as the boilers needed huge quantities of water, rainwater tanks were built into the foundations of the inner courtyard. Accommodation was built in the form of small cosy cottages for the lighthouse staff and their families. At times there could be as many as four keepers and the engineer who was in charge. Surprisingly the lighthouse is only 345 yards from the steep cliff edges and she began saving lives in January 1871. Trinity House announced the decommissioning of Souter in 1988 as the advancement of GPS technology made many lighthouses obsolete.

Today, the lighthouse is owned and maintained by the National Trust. It remains a source of pride and a beacon to our proud maritime and industrial past.